WEDDING
PHOTOGRAPHER'S
HANDBOOK

BILL HURTER

AMHERST MEDIA, INC. ■ BUFFALO, NY

Front cover photograph by Frank Cava.
Back cover photograph by Cal Landau.

Published by:
Amherst Media, Inc.
P.O. Box 586
Buffalo, N.Y. 14226
Fax: 716-874-4508
www.AmherstMedia.com

Publisher: Craig Alesse
Senior Editor/Production Manager: Michelle Perkins
Assistant Editor: Barbara A. Lynch-Johnt

ISBN-13: 978-1-58428-191-4
Library of Congress Card Catalog Number: 2006925660

Printed in Korea.
10 9 8 7 6 5 4 3 2 1

TABLE OF CONTENTS

ABOUT THE AUTHOR

Bill Hurter started out in photography in 1972 in Washington, DC, where he was a news photographer. He even covered the political scene—including the Watergate hearings. After graduating with a BA in literature from American University in 1972, he completed training at the Brooks Institute of Photography in 1975. Going on to work at Petersen's PhotoGraphic magazine, he held practically every job except art director. He has been the owner of his own creative agency, shot stock, and worked assignments (including a year or so with the L.A. Dodgers). He has been directly involved in photography for the last thirty years and has seen the revolution in technology. In 1988, Bill was awarded an honorary Masters of Science degree from the Brooks Institute. He has written more than a dozen instructional books for professional photographers and is currently the editor of *Rangefinder* magazine.

1.
INTRODUCTION

*I*n the earliest days of photography, weddings were photographed in styles that captured the bride and groom in very formal poses. Even with the emergence of the contemporary wedding album, which included group portraits of statuesque groomsmen and bridesmaids and the bride and groom with family members, posing remained stiff and lifeless. As wedding photography progressed, posing techniques still closely mirrored the posing techniques of the great 18th century English portrait artists, like Thomas Gainsborough and Joshua Reynolds.

BELOW—Many brides want spontaneity and real moments recorded at their wedding; the kind only a gifted wedding photojournalist, skilled at observation and with fast reflexes, could provide. Photograph by Marcus Bell. FACING PAGE—David Worthington is a wedding photographer who has great respect for and knowledge of the posing and lighting principles of the traditional wedding photographer, yet combines his traditional skills with a healthy knowledge of digital and Photoshop skills to consistently produce the "idealized" wedding image.

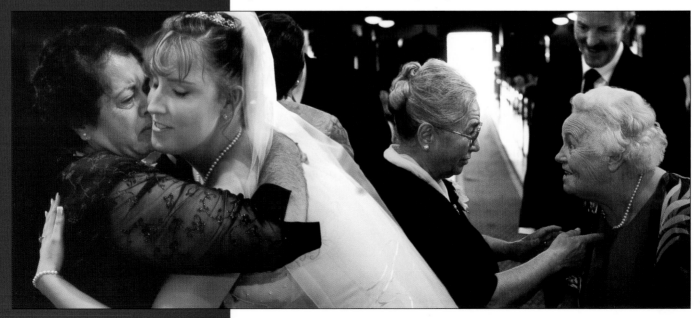

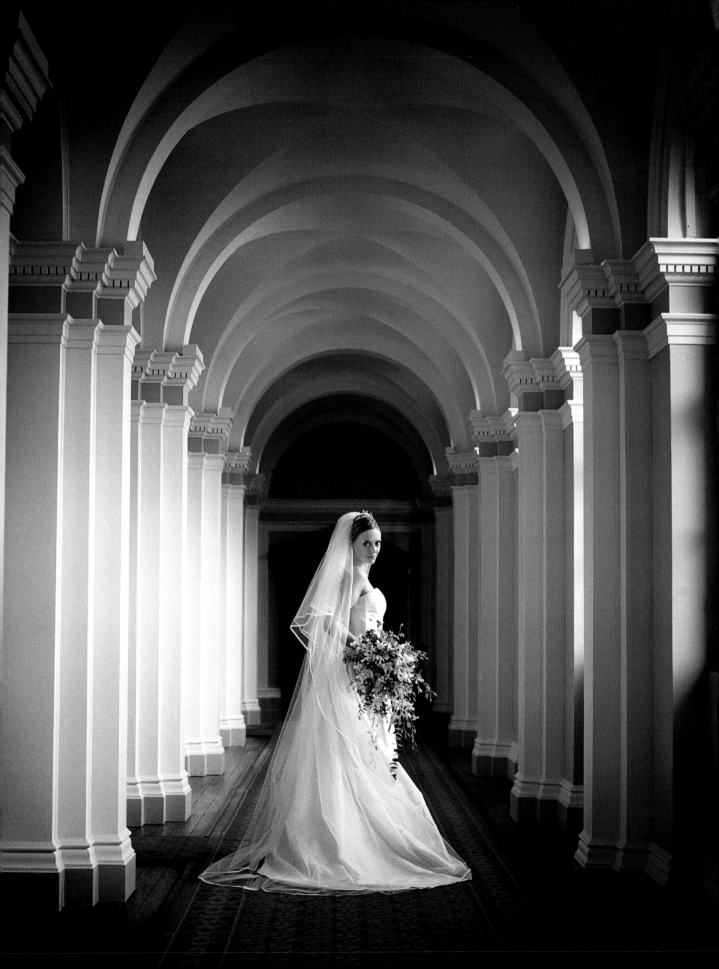

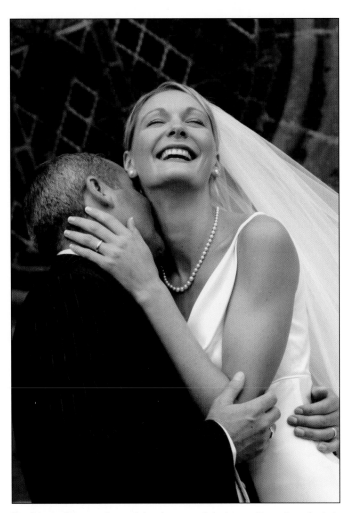

Real emotion, not contrived or scripted emotion, is what is expected by today's brides. Here, the photographer captured a rare moment while making his formal portraits. Photo by Dennis Orchard.

It is against this backdrop or formality that wedding photography evolved—or rather, rebelled. In this early style, each individual photo was a check mark on a long list of posed and often pre-arranged images from a "shot list" stuffed in the vest pocket of the wedding photographer's tuxedo. Even spontaneous events like the bouquet toss and cake cutting were orchestrated to reflect the classical posing techniques. Spontaneity had all but disappeared from this most joyous of ceremonies. Amidst such a regimented creative environment, it is not at all difficult to see why there was an active rebellion among brides and wedding photographers. In short, this rebellion turned the world of wedding photography upside down.

A class of wedding photographers known as wedding photojournalists, spurred on by their unbending leader, the articulate and provocative Denis Reggie, rebelled against the lifelessness of the art form. These wedding photojournalists believe that capturing the emotion of the moment is paramount to good wedding imagery. The record of the naturally unfolding story of the day's events would be the end result of such a mindset.

Everything about the methods and techniques of the wedding photojournalist was different than those of the traditional wedding photographer. The new breed shot unobserved with fast film using available light. They used 35mm SLRs with motor drives, as opposed to Hasselblads, and on-camera flash became a last resort for the wedding photojournalist.

As you might have guessed, traditionalists recoiled in horror at this new breed of wedding photographer. They denounced the grainy and often out-of-focus "grab shots" created by the photojournalists, and they predicted that the final days of wedding photography as a profitable and predictable livelihood were at hand, noting that every photographer with a 35mm SLR would soon take over the niche of the professional wedding photographer.

Instead, for the first time, brides were now able to make real choices about how they wanted their once-in-a-lifetime day recorded. In addition to pristine color and a wealth of storytelling black & white imagery, brides were now able to choose from a diverse range of styles, imagery, and presentation. Add to the mix the incredible and explosive creativity introduced by the advent of digital imaging and we now find ourselves in the midst of a true Renaissance.

Once viewed as a near-deplorable way to make a living, wedding photography now draws the best and brightest photographers into its ranks. It is an art form that is virtually exploding with creativity—and with wedding budgets seemingly knowing no bounds, the horizons of wedding photography seem limitless.

WEDDING PHOTOGRAPHY EVOLUTION

Since the late 1980s, when wedding photojournalism really took hold, the trend away from traditional wedding photography has continued unabated, but with some surprising twists. The new breed of wedding photographer has no problem directing or choreographing an image, as long as the results are spontaneous and emotion-filled. They don't particularly care if they are purists, in the photojournalistic sense.

The "hot" wedding photographers now are those who favor a fine-art approach to wedding photography. Each image is carefully crafted by the photographer (not the lab) in Photoshop and the effects they produce are just what the contemporary bride has always dreamed of—a unique and one-of-a-kind wedding album.

The modern-day wedding photographer is among the upper echelon of the photographic elite, both in terms of professional status and financial rewards. This book then is a continuing celebration of this great and evolving art form and its fabled artists.

DIGITAL TAKEOVER

The move away from film and towards 100-percent digital capture also continues unabated. Today, digital and wedding photojournalism go hand in hand as the speed and flexibility of digital capture supports this on-the-fly, unobserved shooting style. While today's digital photographers are aware of the increased time and effort involved in being purely digital, new methods of

workflow and image editing continue to evolve, and new software is helping to aid in the transition.

Digital technology is virtually exploding. New digital camera systems are appearing overnight, as are peripheral products that support digital imaging. Almost without exception, manufacturers' entire research-and-development budgets are going into new digital products. New cameras with higher resolution, improved imaging chips with added functionality, and better software for handling RAW files are being introduced with ever-greater frequency.

In addition, whether a photographer shoots weddings digitally or with film, the impact of Adobe Photoshop has permanently changed the style and scope of wedding imagery. In the comfort of their home or studio, photographers can now routinely accomplish creative effects that previously could only be achieved by an expert darkroom technician or retoucher. Photoshop has made wedding photography the most creative venue in all of photography—and brides love it. Digital

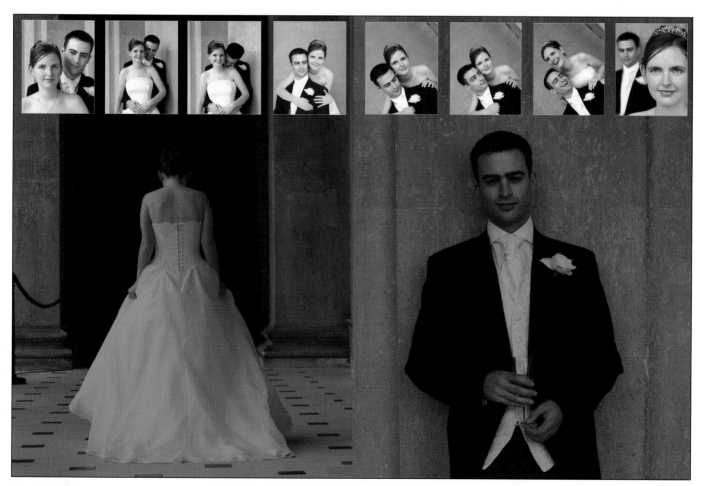

The digital wedding album has been responsible for changing both the economics and the expectations of contemporary wedding photography. Photography and album design by Stuart Bebb.

Digital albums represent a new level of creativity. Notice how David Williams has combined unusually effective images and design elements in a single album page. Note the horizon line that intersects with the black and white for a playful, interesting effect.

albums, assembled in Photoshop, have become the preferred album type, and the style and uniqueness these albums bring to the wedding experience make every bride and groom a celebrity.

Digital capture also provides the ability to instantly preview images, meaning that if you missed the shot for whatever reason, you can redo it right then and there. That kind of insurance is priceless. The ability to review an image on the camera's LCD monitor is one of the tremendous benefits of digital capture. Sometimes, it may take a few test shots to adjust the camera perfectly, but that's infinitely better than shooting several rolls and then waiting until after the wedding to see what happened.

Also, the flexibility of digital capture is unsurpassed. You can change film speeds from ISO 100 to ISO 1600 or higher from frame to frame. You can alter the white balance at any time to correct the color balance of the lighting. With certain cameras you can even change from color to black & white at the touch of a button. The creative freedom afforded by digital capture is unprecedented.

However, one of the biggest complaints of wedding photographers who have gone digital is the tedious post-shoot workflow. Some wedding photographers find that they are paying the same amount for prints from digital labs, yet they have to take on many of the tasks that were previously done by the lab. So more personnel are needed to "work" the files and the money saved in film and processing charges goes right back into expensive digital equipment, more computers, and ever-changing technology. More than the cost, the time

spent in front of a computer monitor has drastically increased.

What is often not discussed is the ultimate control of each and every image shot digitally. The photographers featured in this book are digital artists, and while they are not above using time-saving shortcuts in the image-processing side of things, they still spend a great deal of time perfecting each photograph that goes out to a client. Perhaps this aspect of contemporary wedding photography, more than any other, has accounted for the profound increase in artistic wedding images.

Simultaneously, this fine-art approach has raised the bar financially for wedding photographers, allowing them to charge mind-boggling prices for their wedding coverage. Says photographer David Beckstead, "I treat each and every image as an art piece. If you pay this much attention to the details of the final image, brides will pick up on this and often replace the word 'photographer' with the word 'artist.'" That simple shift in emphasis has made fortunes for many of today's wedding photographers. Albeit a select group, the contemporary wedding photographer could represent the highest paid segment of photographers anywhere—a far cry from the "weekend warriors" of 40 years ago.

The Internet also plays a huge role in the life of every digital wedding photographer. Online proofing and sales have become a big part of every wedding package. Couples can check out "the take" of images while on their honeymoon by going to the photographer's password-protected web site—all from the comfort of their hotel room or a digital café. And there is scarcely a single successful wedding photographer who does not have a first-rate web site that attracts new clients and out-of-town bookings.

David Beckstead has worked hard to develop his fine-art approach to wedding photography. This strategy has paid off—both financially and artistically.

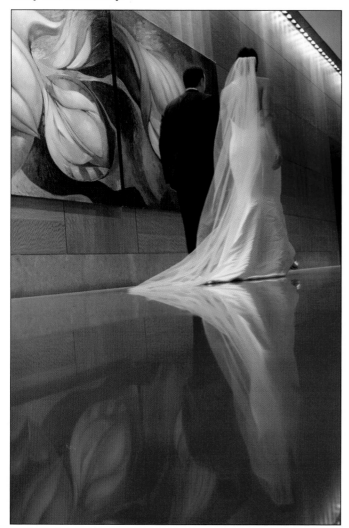

Other recent developments include the use of FTP (file transfer protocol) sites for transferring files to the lab for proofing. Also popular is printing or album-design software that relies on the use of small, manageable files, called proxies, which allow the photographer to quickly and fluidly design the album and upload it for proofing or printing.

As you will see from the photographs throughout this book, the range of creativity and uniqueness displayed by today's top digital wedding photographers is incomparable. I wish to thank the many photographers who have contributed to this book—not only for their images, but also for their expertise.

I also wish to thank the many photographers who shared trade secrets with me for the purposes of illuminating others. Some of their tips and tidbits, which appear throughout the book, are as ingenious as they are invaluable. While no book can equal years of wedding photography experience, it is my hope that you will learn from these masters how the best wedding photography is created—with style, artistry, technical excellence, and professionalism.

David Beckstead creates and refines every image to produce a unique work of art. As a result, his clients think of him as an artist, not just a wedding photographer.

THE WEDDING PHOTOGRAPHER'S MINDSET

To be successful as a wedding photographer, you have to master a variety of different types of coverage, perform under pressure, and work in a very limited time frame. No other photographic specialty is more demanding. The couple and their families have made a considerable financial investment in the (hopefully) once-in-a-life-

Here four bridesmaids and the bride make their way down to the church. At best, it's an average photo op, but Dennis Orchard made them come alive—even to the onlookers—for an unforgettable shot.

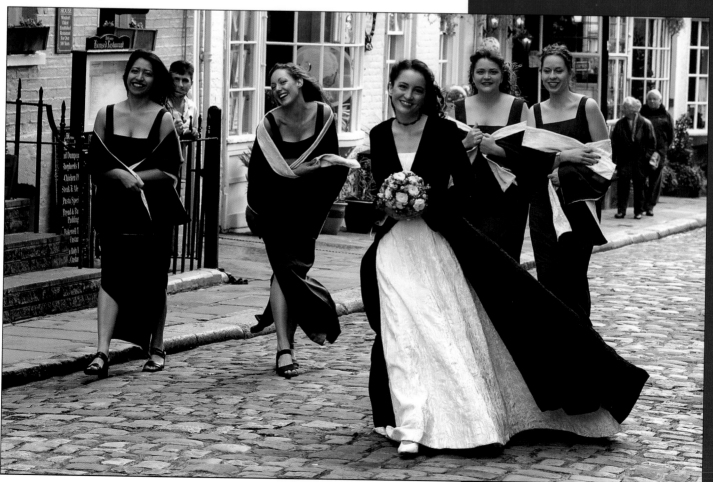

\mathcal{M}any wedding photographers religiously scour bridal magazines, studying the various forms of editorial and advertising photography. Editorial style has become a major influence on wedding photography. These magazines are what prospective brides look at and, as a result, they want their wedding photography to imitate what they see in them.

time event. Should anything go wrong photographically, the event cannot be re-shot.

Aside from the obvious photographic skills, successful wedding photography takes calm nerves and the ability to perform at the highest levels under stress. The couple is not looking for general competence; they are looking for brilliance. They don't just want a photographic "record" of the day's events, they want inspired, imaginative images and an unforgettable presentation. To all but the jaded, the wedding day is the biggest day in peoples' lives, and the images should capture all of the romance, joy, and festivity with style. This intense pressure is why many gifted photographers do not pursue wedding photography as their main occupation.

As a result of these factors, the truly gifted wedding photographer is a great observer. He or she sees the myriad of fleeting moments that all too often go unrecorded. The experienced professional knows that the wedding day is overflowing with these special moments and that capturing them is the essence of great wedding photography. Above and beyond this quality, however, there are a variety of other factors that can impact upon a wedding photographer's success.

DRESSING FOR SUCCESS

One might expect the wedding photojournalist to dress down for the wedding—maybe not like the sports photographer with knee pads and a photographer's vest and jeans, but casual. Tony Florez, a very successful

Tony Florez is a popular wedding photographer who incorporates different types of editorial styles into his wedding images. He is well known for producing "fine art" images for his brides. Here he chose a unique overhead lighting that created dramatic shadows in the bridal portrait.

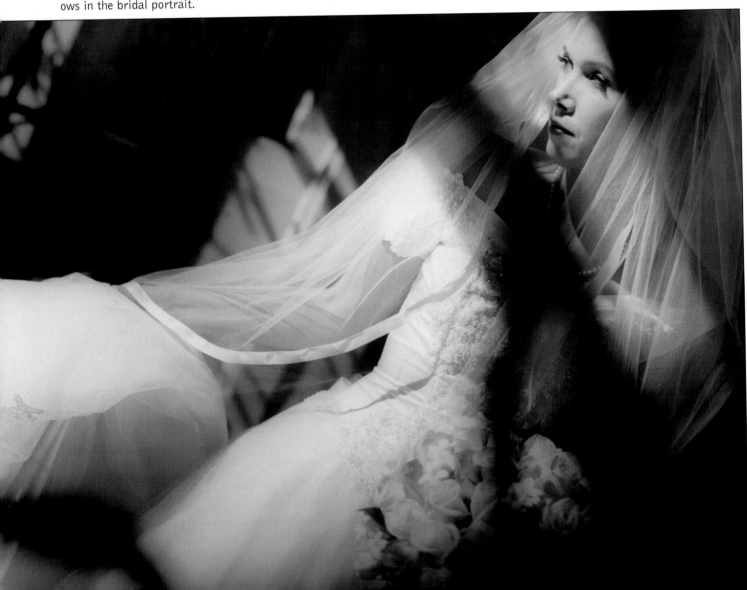

wedding photographer from Newport Beach, California, believes one of the keys to upscaling his business was to live the motto, "dress for success." He only wears Armani tuxedos to his weddings and he, like the couple he is there to photograph, looks like a million dollars. That's not to say that this is the secret to his success—he is a gifted photographer, but his look has added to his confidence and his reputation. Florez has photographed such celebrities as Tom Hanks, Paul Newman, Nicholas Cage, and Lisa Marie Presley and his work has been published in such places as *InStyle*, *People*, People.com, Lifetime Television, *Elegant Bride,* and *Modern Bride.*

IDEALIZATION

Traditional wedding photography is, to some, the quest for perfection. The photographer manipulates the pose, lighting, and expression with the goal of idealizing the subject. To be sure, traditional portraiture and traditional wedding coverage are viable, artistically relevant pursuits, but they are not necessarily the mindset of the wedding photojournalist, to whom the pursuit of rigid perfection is not the goal. Instead, the ideal is to capture the reality and spontaneity of the situation with as little interference as possible.

Joe Buissink excels at giving the bride all the elegance and sophistication she dreamed of. Joe takes in everything around him because of a state of heightened awareness. He translates those details into remarkable images of the wedding day.

Still, the photojournalist's record of the day should be sensitive. Indeed, one of the traits that separate the competent wedding photographers from the great ones is the ability to idealize. The photographer must depict people in a way that makes them look their best. This recognition must be instantaneous and the photographer must also have the skills to make these adjustments in the pictures. In short, wedding photographers need to be magicians. Through careful composition, posing and lighting, and a healthy knowledge of Photoshop, many "imperfections" can be rendered unnoticeable.

Dennis Orchard, a noted English wedding photographer, thrives on this challenge. "I love to make the ordinary become extraordinary. I thrive on average brides and grooms, Travel Lodge Hotels, and rainy days in winter." Orchard knows it is especially important that the bride be made to look as beautiful as possible—most women will spend more time and money on their appearance for their wedding day than for any other day in their lives. Recently, Orchard photographed a 275-pound bride who was, "so frightened of the camera that every time I pointed it at her she would lose her breath and have a mini anxiety attack." Using long lenses, he photographed her all day long without her being aware of the camera. He said he couldn't believe the final shots. "She was beautiful in every frame," he says. She later wrote him a note in which she said, "I never thought I could have pictures like this of me!" It was his best wedding of the year.

The truly talented wedding photographer will also idealize the other events of the day, looking for every opportunity to infuse emotion and love into the wedding pictures. Part of this process is to notice the details of the day—the place settings and floral arrangements, the tables and grounds of the reception—and capture them as part of the day's coverage.

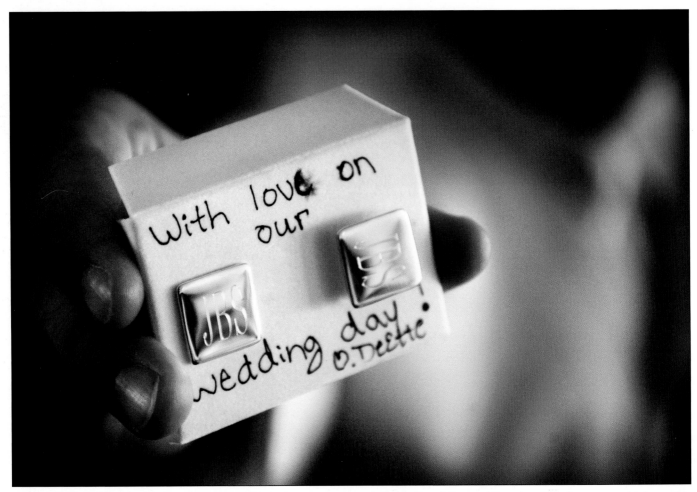

ABOVE—A fine wedding photographer recognizes and captures the small details of the wedding day, like the smeared ink on this message from the bride to her groom on the wedding day. Years later, this image will bring tears of remembrance to her eyes. Photograph by Anthony Cava. FACING PAGE—Anthony Cava is also an expert at photographing the bride so that she looks better than ever. He chooses the right camera height and beautiful lighting to enhance not only the bride's features but also her beautiful gown.

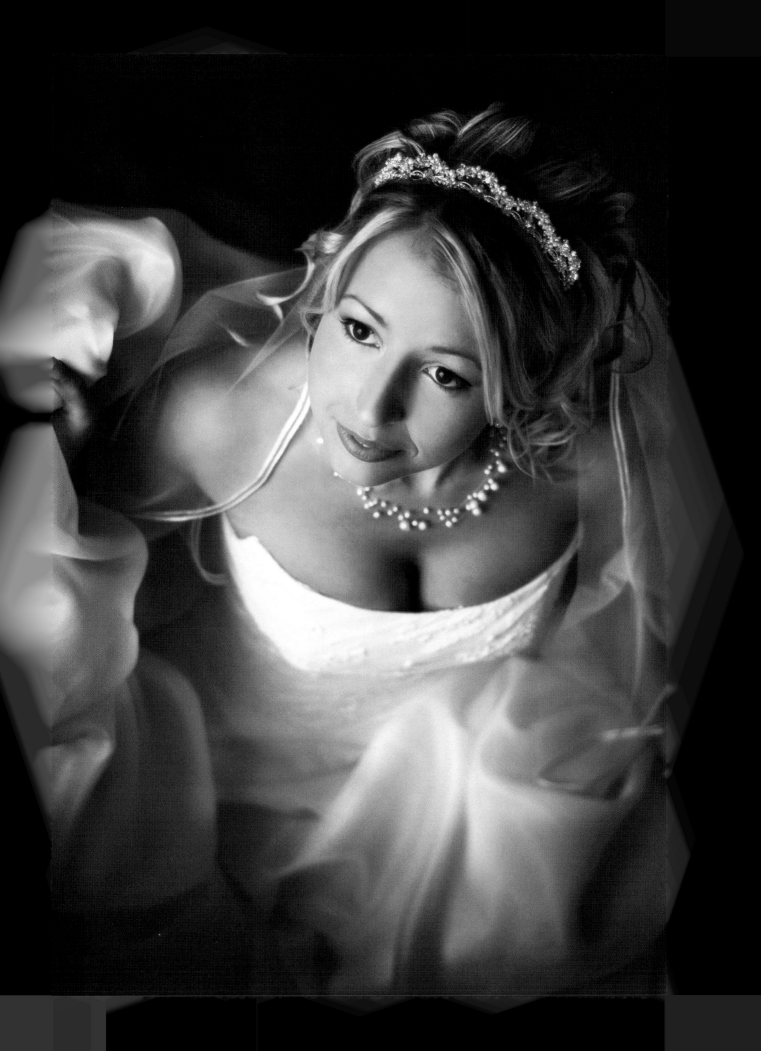

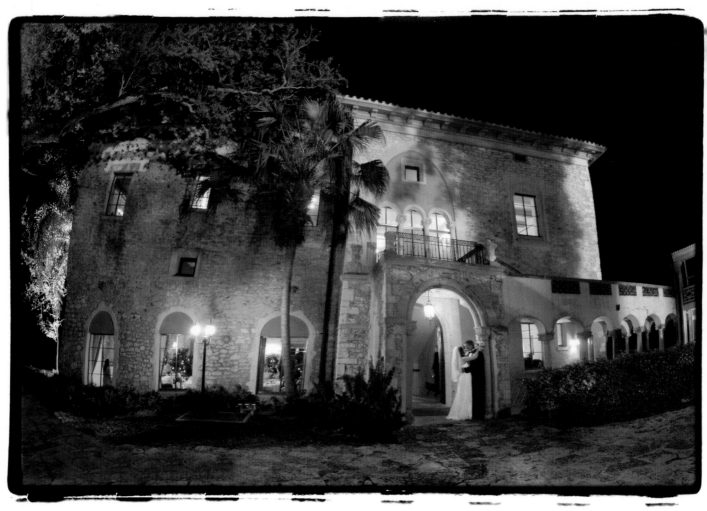

In this image by Jeff Kolodny, he usesd every light on the premises to illuminate the building and grounds, memorializing the spectacular location of the couple's wedding.

PROACTIVE VS. REACTIVE

Traditional wedding coverage features dozens of posed pictures pulled from a "shot list," which has been passed down by generations of other wedding photographers. There may be as many as 75 scripted shots—from cutting the cake, to tossing the garter, to the father of the bride walking his daughter down the aisle. In addition to scripted moments, traditional photographers fill in the album with so-called "candids," many of which are staged or at least taken with the subjects aware of the camera.

*P*hotojournalists are often perceived as detached, but this is a function of the concentration it takes to anticipate and observe the key action and the key elements of the story within all of the mayhem that is the wedding and reception. It is human nature to get caught up in the emotion and want to join in the festivities, but the photographer who indulges this impulse will most certainly lose his or her edge.

The contemporary wedding photographer's approach is quite different. Instead of being a part of every event, moving people around and staging the action, the photographer tends to be quietly invisible, choosing to fade into the background so the subjects are not aware of his presence. The photographer does not want to intrude on the scene. Instead, he or she documents it from a distance with the use of longer-than-normal lenses and, usually, without flash. This is what digital capture offers; a completely self-contained means of documenting a wedding unobserved.

Because the photographer is working with longer lenses or zoom lenses and is not directing the participants, he or she is free to move around and work quickly and unobtrusively. The allows the event itself to take precedence over the photographer's directions—and the resulting pictures are more spontaneous and lifelike. Plus, there are many more opportunities for original,

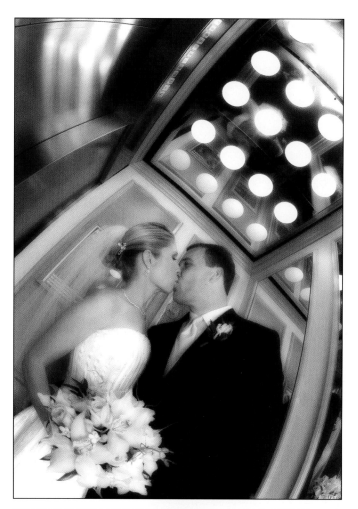

TOP—Working within the confines of an elevator with a fisheye lens is hardly "working unobserved," but the picture doesn't telegraph the photographer, only the moment. Photograph by Jeff Kolodny. BOTTOM—A major component of the wedding day is unbridled joy, which is there to be captured by the observant photographer. Photograph by Mark Cafiero.

completely unstaged images that better tell the story of the event.

POWERS OF OBSERVATION

One of the prerequisites to success is the skill of observation, an intense power to concentrate on the events at hand. Through keen observation, a skill set that can be clearly enhanced through practice, the photographer begins to develop the knack of predicting what will happen next. Knowing what comes next is partially a result of experience (the more weddings one photographs, the more accustomed one becomes to their rhythm and flow), but it is also a function of clearly seeing what is transpiring in front of you and reacting to it quickly.

Knowing the course of the day's events is also critical and requires doing your homework as the photographer. The more the photographer knows of the scheduled events and their order, the better he or she can be at predetermining the best ways to cover those events. This kind of detailed information will provide a game plan and specifics for where to best photograph each of the day's events.

It's also important to keep in mind that there is an ebb and flow to every action. Most wedding photojournalists revere the work and philosophy of Henri Cartier-Bresson, who believed in the concept of "the decisive moment"—a single instant released from the continuity of time by the photographer's skills. This moment is life defining; it is a moment like no other before or since, that defines the reality of the participants.

Revealing the decisive moment can only be accomplished through a full awareness of the scene. Even with motor drives capable of recording six or more frames per second, it is not a question of blanketing a scene with high-speed exposures; it is knowing when to press the shutter release. This requires concentration, discipline, and sensitivity.

Photographers like Joe Buissink accomplish this by becoming one with their equipment, the moment, and the emotion of the wedding couple. Buissink considers

ABOVE—Joe Buissink is so absorbed in the events and flow of the wedding day that he is almost invisible to the participants. He seeks out the emotion-filled moments so plentiful on the wedding day. LEFT—For Joe Buissink, being in the moment means maintaining a state of heightened concentration and awareness. In this state, he is able to reveal truly rare moments as they occur throughout the wedding day. The moments he looks for and reacts to often reflect the profound love and emotion found on wedding days.

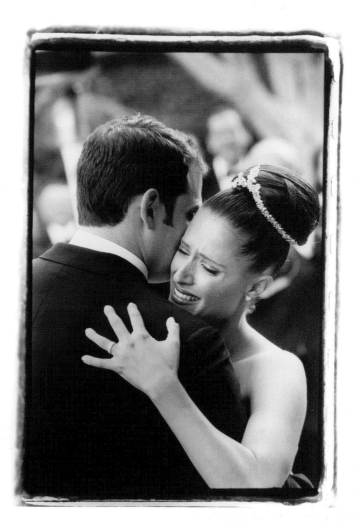

Joe Buissink trusts his basic instincts and as a result, many more great opportunities seem to present themselves to his lens.

his equipment to be an extension of his body, his eye and his heart. His cameras and lenses and his techniques are so second nature that all he needs to do is grab the right body with the right lens and fire away. His sense of positioning is also near perfect, based on a foreknowledge of the events and an attention to the details of every wedding he photographs.

Buissink's levels of concentration are legendary; it's a state he calls "being in the moment." He says of the state, "My sense of self fades away. I dance with the moment . . . capturing the essence of a couple." Joe may be "in the moment" for up to 10 hours, the time given to photograph his average wedding. This concept of immersion takes Joe a few days to recover from, as he is mentally exhausted after a wedding.

Part of one's skills as a polished observer also result from being calm and quiet. Buissink says, "You must relax enough to be yourself and exhibit your pleasure in creating art. Do not look for the flow, it will find you.

If you try to force it, it will be lost." As a photojournalist, you cannot become part of the spectacle you are covering. Otherwise you will miss the day's most meaningful moments. "Trust your intuition so that you can react," Buissink says. "Do not think. Just react or it will be too late."

VISION

David Anthony Williams, an Australian wedding and portrait photographer, believes that the key ingredient to great wedding photos is something he once read that was attributed to the great Magnum photographer, Elliot Erwitt: "Good photography is not about zone printing or any other Ansel Adams nonsense. It's about seeing. You either see or you don't see. The rest is academic. Photography is simply a function of noticing things. Nothing more." Williams, who is quite articulate on the subject, goes on to say, "Good wedding photography is not about complicated posing, sumptu-

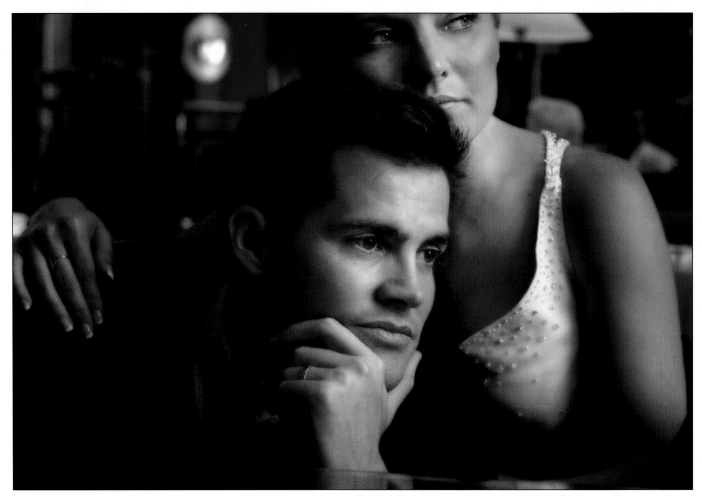

David Williams might take a moment, found or observed, and embellish it, taking advantage of all of the natural surroundings. Here he fashioned a romantic and elegant portrait of the couple that grew out of a moment of relaxation.

ous backgrounds, or five lights used brilliantly. It is about expression, interaction, and life! The rest is important, but secondary."

Williams throws himself into the day with the zest of one of the primary participants. He says, "I just love it when people think I'm a friend of the couple they just haven't met yet, who happens to do photography." This level of involvement, plus preparation and solid photographic skills, leads to great pictures.

With the best wedding photographers, technical skills are refined and second nature. Arizona wedding specialist Ken Sklute photographed 150 to 200 weddings a year for over 10 years. To say he has his technique down is an understatement, yet his images are always refreshing and beautiful. He is also a devotee of the concept of immersion. Ken believes that the emotion within the moment is the heart of every great picture. And it's no surprise that he is phenomenal with people—getting them to both relax and be themselves

and yet be more beautiful or handsome than they've ever been before.

Both Williams and Sklute can make anyone look good, but their real gift is that ability to create the animated, full-of-life portrait. It is the best of both worlds: the real and the idealized. Certainly part of the success is technique, but the less tangible ingredient is the interaction. It's interaction and communication, but also a little magic.

STORYTELLERS

Above all, the skilled wedding photojournalist is an expert storyteller. The wedding day is a collection of short stories or chapters that, when pulled together, tell the story of an entire day. A good storyteller is aware of the elements of good narrative (a beginning, a middle and an end), as well as the aspects that make a story entertaining to experience—emotion, humor, tension, plot, resolution, pathos, and so on. Linking the sponta-

RIGHT—David Williams incorporates the details of the day (the makeup order, brushes, a close-up of the bride having her makeup applied) with the big picture (the bridesmaids and a lovely portrait of the bride) to form a lovely page in the final album. BOTTOM LEFT—The use of henna as a body decoration for an Indian wedding is a common practice. Here, Joe Photo recognized the similarities between the gown and the hands and photographed the two in a meaningful way. BOTTOM RIGHT—The photojournalist's mindset is to be in the right place at the right time and have the reflexes of a cat. Photography by Mark Cafiero.

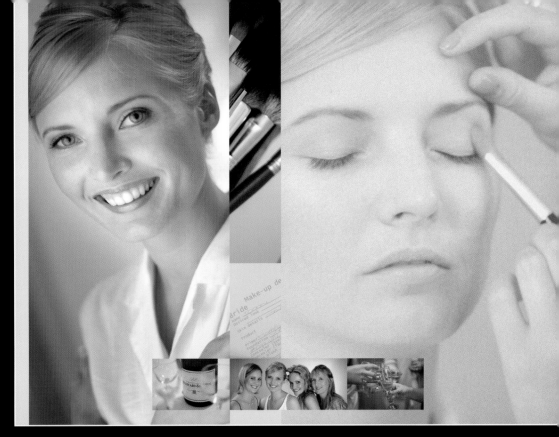

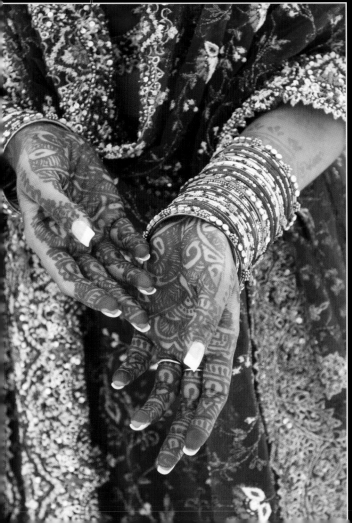

neous events of the day forms the wedding-day story, which is what the modern bride wants to see in her wedding coverage.

According to award-winning wedding photographer Charles Maring, a good story includes many details that go unobserved by most people—even those attending the event. He says, "Studying food and wine magazines, fashion magazines, and various other aspects of editorial images has made me think about the subtle aspects that surround me at a wedding. Chefs are preparing, bartenders are serving, waiters are pouring champagne or wine. My goal is to bring to life the whole story from

BELOW AND FACING PAGE—Charles Maring makes a special effort to elegantly photograph the various background elements of the day because he feels their inclusion helps to completely tell the wedding story.

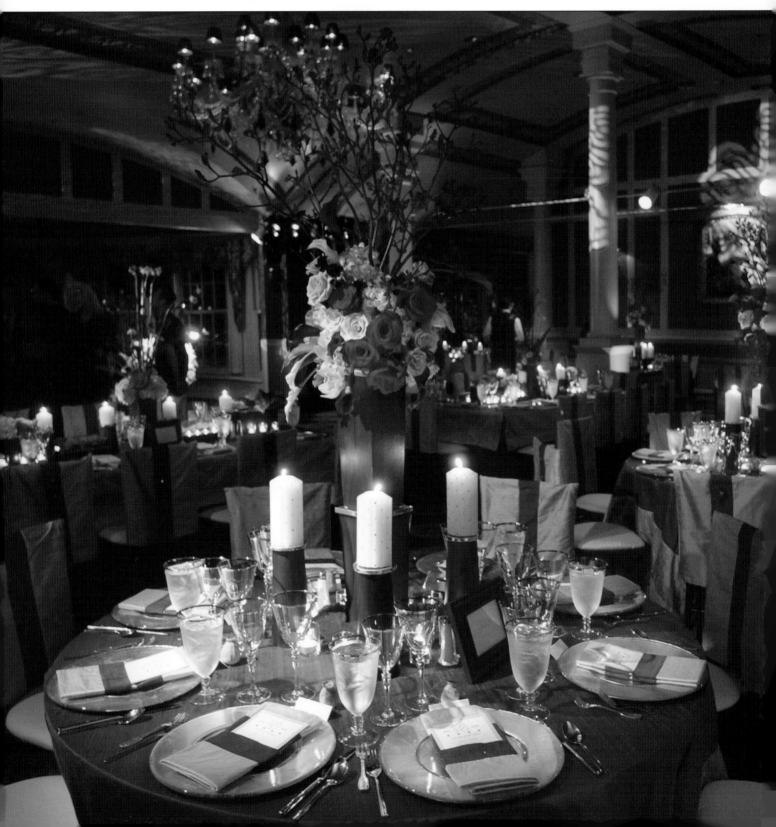

behind the scenes, to the nature around the day, to the scene setters, to the blatantly obvious. In short, to capture a complete story."

David Williams uses a similar strategy, making it a point to shoot several rounds of what he calls "detail minis," which are all shot with a 50mm f/1.4 lens wide open. These shots portray the little artistic details, like a crest, a spoon, a light, or a row of candles. In the background, these elements bring beauty and texture to an event, but are not necessarily noticed by all those who attend.

ASSISTANTS

Assistants can run interference for you, downloading memory cards so that they can be reused, burning CD backups on the laptop, organizing guests for a group shots, helping you by taking flash readings and predetermining exposure, taping light stands and cords

Jeffrey and Julia Woods are a husband-and-wife team who work the wedding day together, each with different assignments. This photograph was a result of having a shooter positioned to capture the bride and groom as they came up the aisle after the ceremony.

Most assistants go on to become full-fledged wedding photographers. After you've developed confidence in an assistant, he or she can help you photograph the wedding—particularly at the reception when there are too many things going on at once for one person to cover. Most assistants will try to work for several different wedding photographers to broaden their range of experience. It's a good idea to employ several assistants, so that if you get a really big job you can use both of them, or if one is unavailable you have a backup.

Assistants also make good security guards against photographers' gear "disappearing" at weddings. A friend, who shall remain nameless, lost his entire cache of camera gear at the church, being left with only the camera he was shooting with to cover the reception. He has obviously instituted a security plan that now deals with that possibility.

Many husband and wife teams cover weddings together, creating different types of coverage (formals *vs.* reportage, for example). Many of these teams also use assistants to broaden their coverage into a real team effort.

securely with duct tape and a thousand other chores. They can survey your backgrounds looking for unwanted elements and they can be a moveable light stand, holding your secondary flash for back or side-lighting.

Assistants should be trained in your unique brand of photography so that they know how to best help you. Good assistants will be able to anticipate your needs and help prepare you for upcoming shots. Assistants should also understand your "game plan" and know everything that you know about the details of the day.

PREPARATION

Preparation is the key to anticipating events. By being completely familiar with the format of the ceremony and events, you will know where and when an event will take place and be prepared for it. The wedding photographer must know the clients, and must know the detailed plans for the day, both at the wedding and the reception.

This kind of planning must take place weeks before the wedding day. It is a good idea for the photographer to visit all of the venues at the time of day at which the events will take place. Many photographers take extensive notes on ambient lighting, ceiling height and surfaces, window placement, reflective or light-absorbing surfaces like mirrors or wood paneling, and other physical conditions that will affect the photography.

Another good practice is to schedule an engagement portrait. This has become a classic element of wedding coverage. The portrait can be made virtually anywhere, but it allows the couple to get used to the methods of the photographer, so that on the wedding day they are accustomed to the photographer's rhythms and style of shooting. The experience also helps the threesome get to know each other better, so the photographer doesn't seem like an outsider on the day of the wedding.

In addition, it is advisable to meet with the principle vendors, such as the florist, caterer, band director, hotel banquet manager and so on to go over the wedding-day plans and itinerary in detail. This kind of detailed information will aid in not only being prepared for what's to come, but it will provide a game plan and specifics for where to best photograph each of the day's events. From such information the photographer will be able to choreograph his or her own movements to be in the optimum position for each phase of the wedding day. The confidence that this kind of preparation provides is immeasurable.

UNIQUENESS

Whether the coverage is classic or totally untraditional, the wedding pictures

must be unique. No two weddings are the same and it is the photographer's responsibility to make images that reflect this. The style may be natural or chic, high energy or laid-back, but uniqueness is the real product people are buying. Brides want distinctive images and they can only come from a photographer exercising his or her individuality in the making and presentation of the photographs. Fortunately, this is also the fun part for the photographer—with the abandonment of the cookie-cutter style of posed portraits, every wedding is a new experience with all-new challenges.

STYLE

Today's wedding coverage reflects an editorial style, pulled from the pages of bridal magazines. Weddings and all the associated accessories have become big busi-

Ken Sklute, who has in his career photographed 150 to 200 weddings a year, never loses site of what the day is all about: the emotion between the bride and groom and the celebrants. Here, the bride was moved to tears by the image of her father, fighting serious illness to be a part of her wedding.

ness and, as such, these bridal magazines are flourishing. Noted Australian wedding photographer Martin Schembri calls the style of the contemporary wedding coverage a "magazine style." It is reminiscent of advertising/fashion photography. If you study these magazines you will notice that there is often very little difference between the advertising photographs and the editorial images used to illustrate articles. Based on an understanding of consumer trends in wedding apparel, the photographer can be better equipped to understand what the bride wants to see in her photographs.

Like Charles Maring, Martin Schembri, who produces elegant magazine-style digital wedding albums, is as much a graphic designer as he is a top-notch photographer. Schembri assimilates design elements from the landscape of the wedding—color, shape, line, architecture, light and shadow—and he also studies the dress,

FACING PAGE—Jeff Kolodny frequently photographs still lifes of the decorations at the reception. These not only become important aspects of the album, but are also good for business when he sends a print to the cake maker and banquet manager. RIGHT—Alisha and Brook Todd, because they work as a team, are experts at isolating the truly rich moments of the wedding day. BELOW—Did Joe Photo prompt this moment or was he just on hand to capture it? The odds are better than even that he was somehow involved. He is gregarious and fun loving by nature.

accessories, color of the bridesmaid's dresses, etc., and then works on creating an overall work of art (i.e., the album) that reflects these design elements on every page.

PEOPLE SKILLS

Any good wedding photographer needs to be a "people person," capable of inspiring trust in the bride and groom. Generally speaking, wedding photojournalists are more reactive than proactive, but they cannot be flies on the wall for the entire day. Interaction with the participants at crucial and often very stressful moments during the wedding day is inevitable—and that is when the photographer with people skills really shines.

Joe Buissink, has been blessed with a salt-of-the-earth type personality that makes his clients instantly like and trust him. Such trust leads to complete freedom to capture the event as he sees it. It also helps that Buissink sees the wedding ceremonies as significant and treats the day with great respect. Buissink says of his people skills, "you must hone your communication skills to create a personal rapport with clients, so they will invite you to participate in their special moments." And he stresses the importance of being objective and unencumbered. "Leave your personal baggage at home," he says, "this will allow you to balance the three principle roles of observer, director, and psychologist."

Kevin Kubota, a successful wedding and portrait photographer from the Pacific Northwest, always encourages his couples to be themselves and to wear their emotions on their sleeves. It's a tactic that frees the couple to be themselves throughout the entire day. He tries to get to know the couple as much as possible before the wedding and also encourages his brides and grooms to share their ideas, opening up a dialog of cooperation between client and photographer.

Through my association with Wedding and Portrait Photographers International and *Rangefinder* maga-

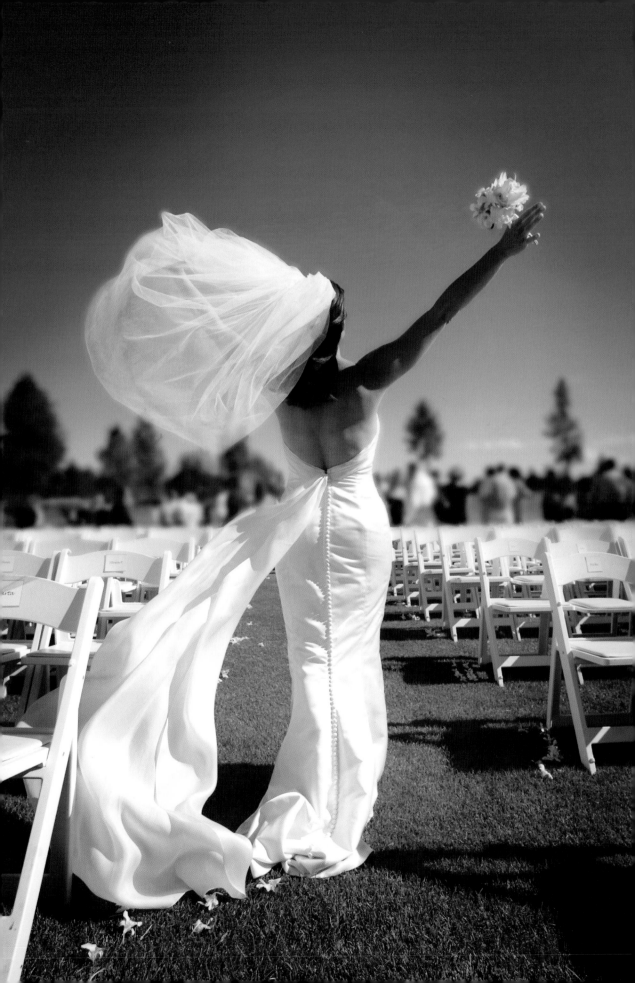

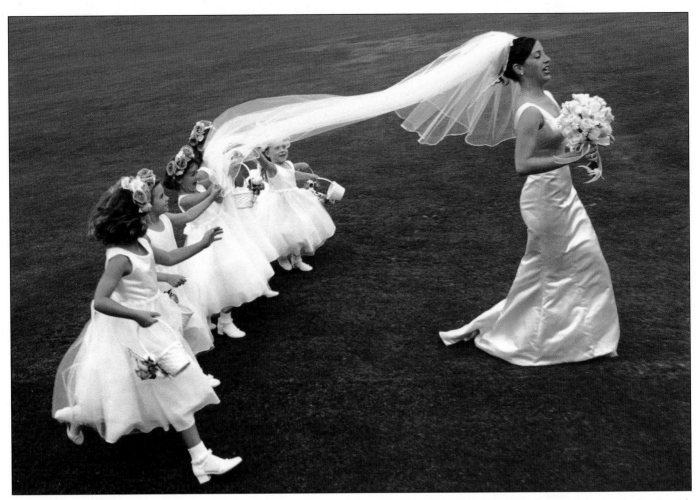

Joe Photo is a master at catching the most enjoyable and entertaining moments of the day. Here, the flower girls are playing "catch the veil," while the bride plays the role of the good sport.

zine, I talk to hundreds of wedding photographers each year and a common thread among the really good ones is an affability and a likability. They are fully at ease with other people and more importantly, they have a sense of self-assuredness that inspires trust.

THE EMOTION OF THE DAY

The successful photographer must be able to feel and relate to the emotion of the event without being drawn in to the extent that they become a participant or lose their sense of objectivity. For Brook and Alisha Todd, two San Francisco-area wedding photographers, this is what the wedding day is all about—and it's why they enjoy being wedding photojournalists. The emotional content that weddings hold for them is the feelings portrayed in these timeless rituals. Their goal in all of their combined coverage is to produce a remembrance of how the bride and groom, and their family and friends, felt on that wedding day.

Perhaps because of the romantic nature of the event, it often helps if the wedding photographer is also a romantic at heart, but it's not completely necessary. For many, the thrill is in the ritual. For others, it's in the celebration. Michael Schuhmann, a gifted wedding photographer from Florida, truly enjoys his work. He explains, "I love to photograph people who are in love and are comfortable expressing it—or so in love that they can't contain it. Then it's real."

Indeed, for many wedding photojournalists, it's not primarily the fees or the prestige that draws them to this speciality, it's simply the chance be part of a meaningful and beautiful ritual. Joe Photo is always up front and part of the wedding day festivities. Personality-wise, he's gregarious and fun loving and is adept at getting people to let loose and have fun. It's no wonder this is his chosen profession. The couple and wedding party all love having him around and want him to involve them in the day's events.

WHY IS WEDDING PHOTOJOURNALISM SO POPULAR?

One of the reasons wedding photojournalism has taken off in popularity is that it emulates the style of photography seen in the bridal magazines, like *Grace Ormonde Wedding Style, Modern Bride,* and *Town & Country.* Before brides even interview photographers, they have become familiar with this type of storytelling editorial imagery.

Even if a shot is scripted, its execution will be much less formal than in past years. This image by Brian Shindle captures a spontaneity that is quite appealing.

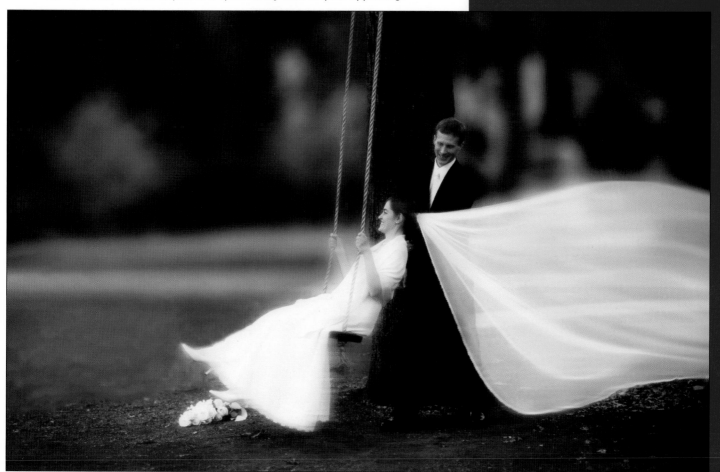

TRADITIONAL WEDDING IMAGES LACK VARIETY

A big reason for the backlash against traditional wedding photography is the "sameness" of it. When this type of scripted coverage is employed, similar if not identical shots will show up in many different albums done by same-minded photographers.

Another reason for the similarity is the types and numbers of formal group portraits. Even with the most elegant posing and lighting, shots can look similar if they are arranged similarly (e.g., bride and groom in the middle, bridesmaids and groomsmen staggered boy-girl to either side). In contrast, when a wedding photojournalist makes group portraits, he or she might make them from the top of a stairwell, or put all the subjects in profile marching down a beach, or have them do something otherwise unpredictable and different. This results in more personalized images and greater variety.

Today's bride doesn't want "cookie-cutter" wedding photographs. She wants unique, heartfelt images that tell the story of her important day.

TRADITIONAL WEDDING IMAGES ARE MORE TIME-CONSUMING TO MAKE

Another potential drawback of the traditional type of wedding coverage is that all those carefully posed pictures take lots of time. In fact, the bigger the wedding, the bigger the bridal party and the bigger the list of "required" shots to make. As a result, the bride and groom can be missing for a good part of their wedding day while they are working with the photographer. The less formal approach leaves couples free to enjoy more of their day.

In this aspect, the photojournalistic system has mutual benefits. While the bride has more time to enjoy her day, the photographer also has more time to observe the subtleties of the wedding day and do his or her best work. I have heard many photographers say that brides and family have told them, "We don't even want to know you're there," which is just fine for most wedding photojournalists.

NO INTRUSION

Because the traditional photographer intrudes on the naturalness of the scene, the coverage is structured

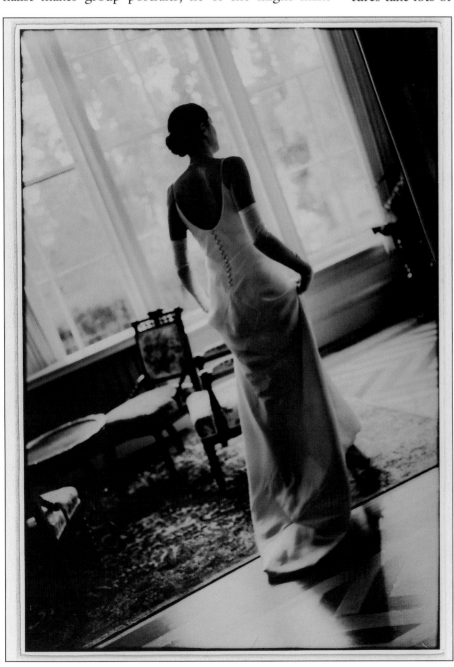

So much of what is included in today's wedding photographer's skill set comes from the world of editorial and fashion. This shot by Becky Burgin is a classic fashion image treated with split-toning by printing master Robert Cavalli.

TOP—The difference between this shot and a traditionalist's version of the same subject is that the photojournalist prefers to capture the unscripted action as it occurs, much like the stop-action coverage of a sports photographer. Photograph by Michael Schuhmann. BOTTOM—Marcus Bell can make himself disappear into the woodwork. Here an exhausted bride and groom take five without a hint that Bell is recording the scene.

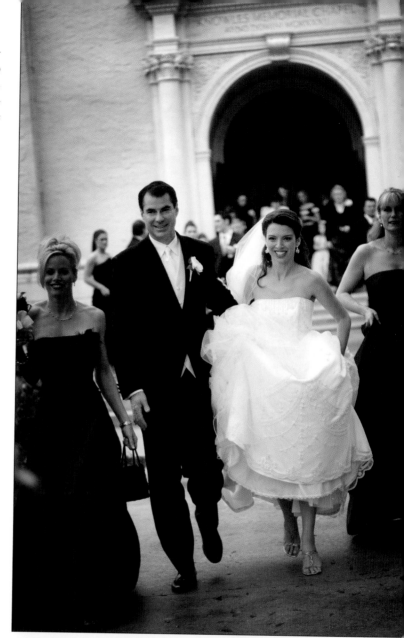

and in the view of many, fictional. When the photojournalist covers the same event, he or she does so without interference and intrusion, allowing the scene to unravel with all of the spontaneity and surprises that will occur at such wonderful events. As a result, the photographer tends to be quietly invisible, choosing to fade into the background so the subjects are not aware of his presence. The event itself then takes precedence over the directions and the resulting pictures are more spontaneous. Many wedding photojournalists even photograph groups with this non-intrusive approach, preferring to wait until things "happen."

EMERGING STYLES

Despite the advantages of wedding photojournalism, photographers who still provide traditional coverage argue that the photojournalist's coverage produces below-average photographs. Indeed, one must acknowledge that some of the most elegant features of traditional portraiture are being thrown out in this creative new approach. After all, the photojournalists can't possibly be as in tune with posing and lighting principles as the masters of the traditional style. Even in many masterful bridal portraits taken by skilled photojournalists, the trained eye may observe poorly posed hands, a confused head-and-shoulders axis, unflattering overhead lighting, and so on. As a result, formal and casual techniques are intermixing more than ever, allowing both photographers and brides to benefit from the best of both styles.

This mixing is particularly evident in group portraiture. The near elimination of formal group portraiture in photojournalistic wedding coverage is now swinging back the other way. All types of wedding photographers are making more group portraits. The main reason for this is that groups sell, and sales mean increased profits. Also, failing to offer such coverage limits the photographer in his or her professional approach. As a result, photographers are offering brides more options, includ-

ing posed formals. Because the choice is theirs, brides (and their parents) seem to be ordering them.

The nature of formal photos is changing, as well, adapting more informal posing and lighting techniques in an effort to preserve the same carefree, relaxed attitude found in the rest of the album. You will also see group portraits made with much more style and elegance than the traditional, straight on-camera flash you saw in wedding groups only twenty years ago. Again,

brides are demanding ever more sophistication in their photographs.

Yes, the classic poses are fading in consideration of a more natural style. However, greater attention to posing fundamentals seems to be evident, as well. After all, these techniques represent time-honored ways of gracefully rendering the human form and revealing character. In the words of Monte Zucker, well known around the world for his traditional wedding portraits, "Photog-

The nature of formals is changing, incorporating elements of traditional styles with a more casual look. Here, an unusual pose and composition along with pristine lighting and exposure make this Drake Busath image an award winner.

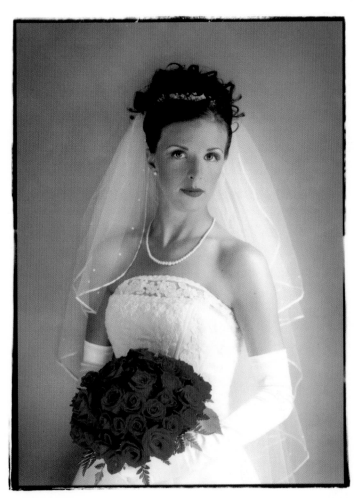

Here are two "formal" bridal portraits taken by the same photographer, Frank Cava, about a year apart. One is decidedly formal and traditional in its posing and lighting, while the other is much more moody and informal. Both have a place in the contemporary wedding album.

raphers are well aware of this [divergence], so they've combined a little of both. My particular style of wedding photography still comes from the fact that I'm more interested in faces and feelings than I am in backgrounds and trends."

This combined approach opens up the best of both worlds for the bride and groom. With an adherence to formal posing principles comes a type of classic elegance that is timeless, with the finely tuned skills of anticipation and observation, on the other hand, the photojournalistic coverage unearths more of the wedding day's wonderful moments. By pairing both approaches, wedding photography is expanding its horizons, and the quality and character of wedding coverage is better today than at any time in the past.

4.
EQUIPMENT

*F*ast, versatile zoom lenses, cameras that operate at burst rates of eight frames-per-second (fps), amazingly accurate autofocus lens performance, and incredible developments in digital imaging technology have led to the 35mm DSLR (digital single-lens re-

There is really no difference, in terms of performance, between images made on CMOS or CCD sensors. This image, by Monte Zucker, was made for an advertising campaign to promote an earlier model of Canon DSLR.

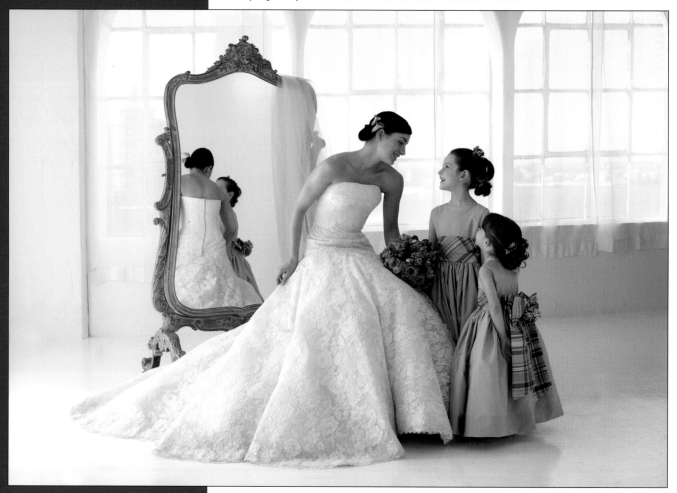

flex) becoming the camera system of choice for today's top wedding photographers.

CAMERAS

Professional 35mm digital camera systems include an array of lenses, dedicated TTL flash units, and system accessories. Currently there are seven full-fledged systems: Canon, Nikon, Olympus, Fuji (which uses Nikon autofocus lenses), Pentax, Minolta/Konica, and Sigma (which uses the radically different Foveon X3 image sensor). Each manufacturer has numerous models within their product line to meet varying price points. Many of the pre-digital lenses available from these same manufacturers for their film cameras also fit the new digital cameras, although often with a corresponding change in focal length. In addition, a number of lens manufacturers also make AF lenses to fit various brands of digital SLRs. These include Tokina, Tamron, and Sigma.

Removable Storage Media. Instead of film, digital cameras store and save digital image files on portable digital media, such as CompactFlash (CF) cards, Memory Sticks, microdrives, and xD cards. The camera writes the image data to the removable storage device as photographs are captured. When the media becomes full, you simply eject it and insert a new card or microdrive just like you would change film at the end of the roll. Removable media are rated and priced according to storage capacity—the more storage capacity, the higher the price.

There are two types of media: flash memory (like CF cards and Memory Sticks) and microdrives (miniature portable hard drives). Flash memory, which uses no moveable parts, tends to perform better than mechanical hard drives under adverse shooting conditions. Some cameras feature dual slots for different media types, others accept only a single type of card. Obviously, the more options you have, the more flexible the camera will be over time. The most common formats at this time seem to be the CF cards (Types I and II) and microdrives.

The write speeds of the different media (how fast data can be recorded by the card) vary from 1.8MB/s (megabytes per second) all the way up to 10MB/s. Write speed is a critical function, especially if you plan to shoot RAW files, which are inherently bulkier than JPEGs. However, the write speed of the media is not

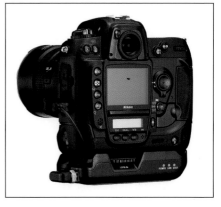

The Nikon D2H is a typical professional DSLR used by the contemporary wedding photographer. This model, in fact, is the one preferred by wedding specialist Joe Buissink. While its sensor size is somewhat smaller than other DSLRs (4.1MP), its burst rate is much faster (8 fps up to 50 [JPEG] or 40 [RAW/NEF] consecutive shots). Attached to the bottom of the camera is the Nikon WT-2A Wireless Transmitter, a Wi-Fi device that allows the captured images to be sent wirelessly to a laptop for processing.

the only determining factor in how fast information will write from the camera to the storage media. The software used by the camera, the file size, and the number of individual files to be written are all determining factors. However, as the crow flies, faster write speed is a desirable quality in storage cards.

Digital images must be uploaded from the camera's removable storage media to a computer. To facilitate this process, a number of digital card readers are available very inexpensively. Of course, the camera can also be connected directly to the computer and the images uploaded in this manner, but a card reader gives the photographer the flexibility of putting the camera back into action immediately—loaded with a fresh memory card. Card readers feature USB 2.0 or FireWire connectivity, which make uploading incredibly fast. Once the images are safely stored on the computer's hard drive and safely backed up on CD or DVD, the memory card can be reformatted and reused.

Image Sensors. Digital cameras use image sensors to record images. Presently there are two main types: CCD and CMOS sensors. While opinions on the aes-

The latest memory card at this writing is the xD card, developed jointly by Fuji and Olympus. The xD card, which uses NAND Flash memory, is very small and provides write speeds up to 3MB per second. Currently, the largest capacity xD card is 512MB, but by the time you read this, it will be up to 8 gigabytes. Various adapters make the cards useable across a wide range of digital cameras.

thetic performance of the two imaging chips vary from pro to pro, both sensor types provide excellent quality image files.

CCDs (charge-coupled devices) record an image in black and white and then pass the light through an array of red, green, and blue filters (called a Bayer filter pattern) to form a color image. The individual filters let only one wavelength of light—red, green, or blue—pass

through to any given imaging site (pixel), allowing it to record only one color.

Like CCDs, CMOS imaging chips (complementary metal oxide semiconductors) use a Bayer filter pattern over the photodetectors. Also included on the CMOS imaging chip, however, is analog signal-processing circuitry that collects and interprets signals generated by the photodiode array. After an image has been obtained,

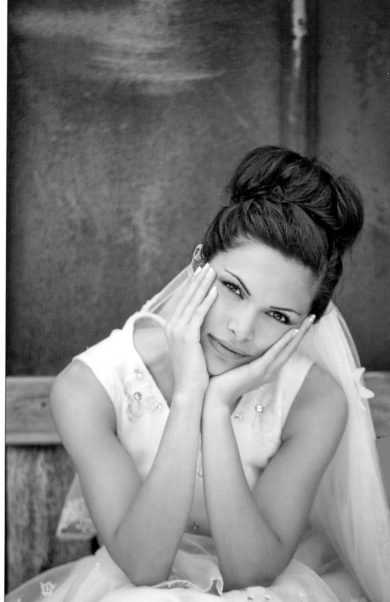

LEFT—When using a DSLR with a full-frame sensor, such as the Canon EOS 1Ds Mark II, the focal length of the lens does not change, so that the zoom setting of 115mm, as was used here, is exactly that, 115mm. Photograph by Dennis Orchard. ABOVE—Marc Weisberg made this wonderful image with a Canon EOS 1D Mark II and 70–200mm f/2.8 lens. The ability of the zoom lens to crop in camera, thus providing the best composition, makes it excellent for the wedding photographer. Image made at 170mm focal length at $^1/_{1250}$ at f/2.8 at ISO 200.

it is amplified and converted into standard red, green, and blue (RGB) format through interpolation systems. CMOS chips are more energy-efficient than CCDs, an important consideration as digital cameras are big-time battery consumers. They are also somewhat less expensive to manufacture.

Although full-frame image sensors now exist, most imaging sensors are smaller than the full 35mm frame size (24x36mm). While the chip size does not necessarily affect image quality or file size, it does change the effective focal length of existing lenses. With sensors smaller than 24x36mm, all lenses get effectively longer in focal length. This is not usually a problem where telephotos and telephoto zooms are concerned, as the maximum aperture of the lens doesn't change. When your expensive wide-angles or wide-angle zooms become sig-

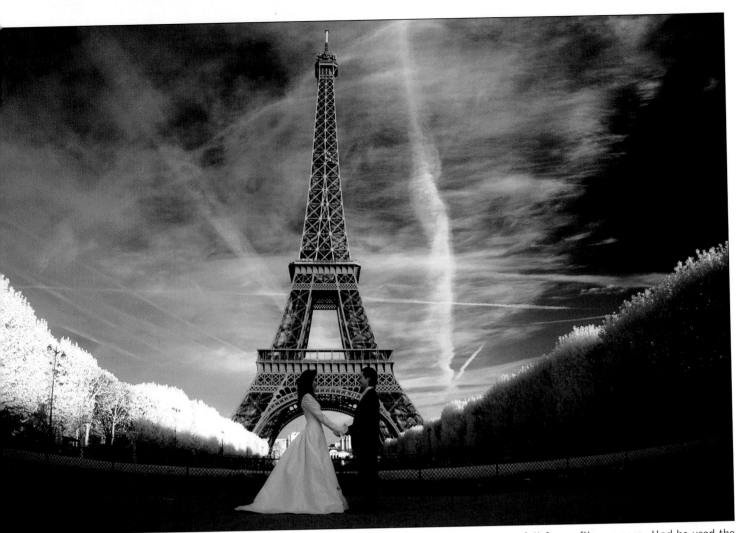

Joe Photo made this stunning portrait of the Eiffel Tower with a 17mm Nikkor lens on a full-frame film camera. Had he used the same lens on his Nikon D1X or D2X, the focal length would have become 25mm (1.5X)—not nearly the wide-angle effect he would have wanted to achieve. Original made on infrared film.

nificantly less wide on the digital camera body, however, it can be disconcerting. A 17mm lens, for example, with a 1.4X lens focal-length factor becomes a 24mm lens.

At this writing, there are two camps: manufacturers who believe full-size sensors are the way to go, and those who believe a smaller sensor is more efficient, cheaper to manufacture, and just as reliable—even if there *is* an effective focal-length magnification. Currently, there are two full-frame sensor cameras available in a DSLR: Canon's flagship EOS 1Ds and the EOS 5D. All other manufacturers are using smaller sensors.

Camera manufacturers who have committed to the smaller image sensor sizes have begun to introduce lens lines specifically designed for digital imaging. The circle of coverage (the area of focused light falling on the film plane or digital-imaging chip) is smaller and more colli-

mated to compensate for the smaller chip size. Thus, the lenses can be made more economically and smaller in size, yet still offer as wide a range of focal lengths as traditional lenses.

Unlike film cameras, the image sensor in a digital camera must be kept clean of dust and other foreign matter in order for it to perform to its optimum level. Depending on the environment where you do most of your shooting, spots may appear on your images. Cleaning the sensor prior to every shoot will help you to minimize or eliminate such spots in your photos.

While each camera manufacturer has different recommendations for cleaning the sensor, Canon digital cameras have a sensor-cleaning mode to which the camera can be set. With the camera's reflex mirror up (a function of the cleaning-mode setting), the company recommends light air from an air syringe to gently

remove any foreign matter. Turning the camera off resets the mirror.

One should realize the image sensor is an extremely delicate device. Do not use propelled air cans, which have airborne propellants that can coat the sensor in a fine mist, worsening the situation.

Intemos (www.intemos.com) markets a liquid-free cleaning product that removes dust and lint from the camera sensor. Lint-free tips with hundreds of micropores, called DSLR Clean Sticks, gently clean a sensor's sensitive surface with a delicate vacuum effect that lifts and traps the unwanted dust. Clean Sticks work with both CCD and CMOS sensors.

Things to Consider When Purchasing a DSLR System. In no particular order, here are some things to consider when purchasing a digital SLR system.

Sensitivity/ISO Range. Most digital camera systems feature a sensitivity range from ISO 100 to 800 or, in some cases, 1600. Some cameras also offer an ISO 3200 setting as a special custom function. Obviously, the wider the gamut of sensitivity, the more useful the camera system will be under a wider range of shooting conditions.

Burst Rate. Unlike film cameras, which use a motor drive to propel the film past the focal plane, there is no film-transport system in a digital camera system. The number of frames per second (FPS) the camera can record is dictated by a number of factors, including write speed (how fast the image can be written to the storage media), file type, and file size. RAW files are larger than JPEGs, for example, and take longer to record, thus the burst rate is slower when shooting RAW files than it is when shooting JPEGs. Typical burst rates range from 2.5fps (frames per second) for up to six shots, all the way up to 8.5fps for up to 48 shots. The spec to look at is the number of consecutive frames that can be captured in a single burst (6, 8, 10, etc.) and the frames-per-second rate (3fps up to 8.5fps).

LCD Monitor. The size and resolution of the camera's LCD screen are important as these screens are highly useful in determining if you got the shot or not. LCD screens range from about 1.8 inches to 2.5 inches and screen resolutions range from around 120,000 to 220,000 dots.

Playback. As important as the physical specifications of the LCD is the number of playback options available.

Some systems let you zoom in on the image to inspect details. Some let you navigate across the image to check different areas of the frame in close-up mode. Some camera systems allow you a thumbnail or proof-sheet review of exposed frames. Some of the more sophisticated systems offer a histogram (to gauge exposure) and highlight-point display to determine if the highlight exposure is accurate or "clipped" (i.e. detail is lost in the bright highlights).

Lens Conversion Factor. The rated focal length of the lens multiplied by the focal-length factor gives the effective focal length. With a 1.6X focal-length factor, for example, a 50mm lens would become an 80mm lens. (*Note:* Lens speed, as mentioned above, is not affected by this conversion. Your f/1.8 lens would still remain an f/1.8 lens.)

Effective Pixels. This is the maximum image size the sensor can record. The spec might be given as 5 million pixels or 5MP (megapixels). Obviously, the higher the number of pixels, the larger the file; the larger the file, the larger the print you can create from it. Some manufacturers also give the spec in terms of Photoshop file sizes—11MB (megabytes) or 18MB TIFFs, for example, since many people think in these terms. It is important to note that some manufacturers use processing algorithms to interpolate resolution. For example, the chip size might be 6MP, yet the standard file size is 12MP because of the software interpolation. The is the case with the Fuji FinePix "S" Pro models.

File Types. The different types of files that DSLRs typically record are RAW files, JPEGs, and TIFF files. JPEGs allow you to shoot more quickly because there is file compression inherent in the format. RAW files provide the maximum amount of information in the captured image.

PC Terminal. Some of the lower-priced DSLRs might seem a bargain until you realize they don't include professional features like a PC terminal for connecting to electronic studio flash.

*D*SLRs go through batteries quickly, so it's essential to pack spare packs. These should be charged and ready to go—even with quick-chargers, you will miss precious opportunities if you are waiting around for the battery pack to charge. You should have enough spares to handle your cameras, your assistants' cameras, and the backup gear.

Michael Schuhmann created this wonderful bridal portrait by using the limited depth of field of a 50mm lens at f/1.4, its widest aperture. The image was made with a Canon 1D Mark II at ISO 250 at $^1\!/_{5300}$ second at f/1.4.

Shutter-Lag Time. This is a spec most camera manufacturers don't provide in their literature, but is important to know before making a purchase. This is the length of time between when you press the shutter release and when the camera actually fires. Consumer and prosumer cameras (consumer cameras with professional features) have substantially longer shutter-response times than professional systems, which are almost instantaneous, but it is still worthwhile testing out each camera in various modes to see the differences between models. Shutter-lag time will directly affect the camera's burst rate. Rates of shutter-release delay time are usually given in milliseconds (thousands of a second) if the spec is even given. An average shutter lag time would be in the area of 50–90ms.

Lens Capability and Accessories. If you're like most professional photographers, you've already invested heavily in one 35mm SLR system. Convincing you to trade in all those lenses and accessories and change to a different brand of camera would take some compelling arguments. Will your current lenses fit the DSLR and will all of their features be useable on the digital camera body? Know the answers to these questions before you invest.

Removable Media. Some cameras feature dual slots for different media types, others accept only certain types of removable cards, like CompactFlash cards. Obviously, the more options you have to use larger and or less expensive media, the more flexible the camera will be over time.

Dimensions/Weight. As with any camera system, ergonomics are extremely important—especially to the wedding photographer, who will be working for hours on end handholding the camera with a variety of lenses. Try the camera out. It might be quite different than even your same-brand film camera.

Battery Power. So, where's the motor drive? It's been turned into a battery pack. Since you don't need motorized film transport, there is no motor drive or winder, but the cameras still look the same because the manufacturers have smartly designed the auxiliary battery packs to look just like a motor or winder attachment. While most of these cameras run on AA batteries, it is advisable to purchase the auxiliary battery packs, since most digital camera systems (especially those with CCD sensors) chew up AAs like jelly beans. Most of the auxiliary battery packs used on DSLRs use rechargeable Lithium-ion batteries.

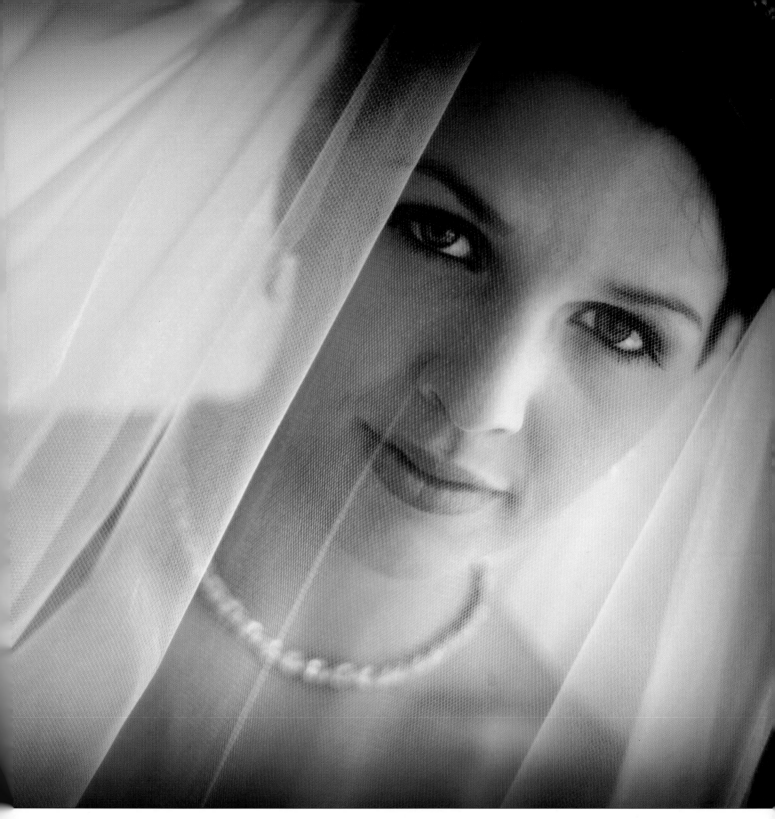

Price. It's not necessarily the price of the flagship camera in a manufacturer's product lineup that's important, but rather it's the range of prices. Many photographers have decided to purchase several top-of-the-line DSLRs and then several of the lower-priced models from the same manufacturer for backup and assistants' cameras. These backups still take the same lenses and removable media cards, but are less expensive than the top-of-the-line cameras.

White Balance. White balance determines the color balance of the recorded image. It can be set individually for each series of shots you make (like applying a color-correction filter). Some manufacturers offer a wide range of white-balance options that correspond to

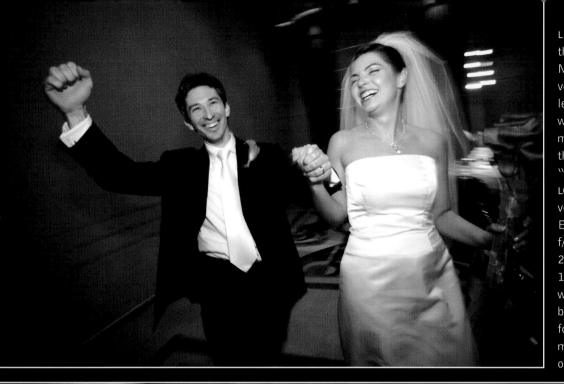

LEFT—Walking backwards as the couple approached, Laura Novak made this photo at very close range with a 17mm lens and a Canon EOS 5D with flash. Because she had metered for the ambient light, the photo does not have a "straight flash" look. BELOW—Laura Novak made this very cool shot with a Canon ESO 20D and EF 17–40mm f/4L lens. Because of the 20D's focal length factor of 1.6X, the 17mm setting, at which this image was made, became a 27mm effective focal length. The image was made at ISO 400 at $1/30$ second at f/4.0 with flash.

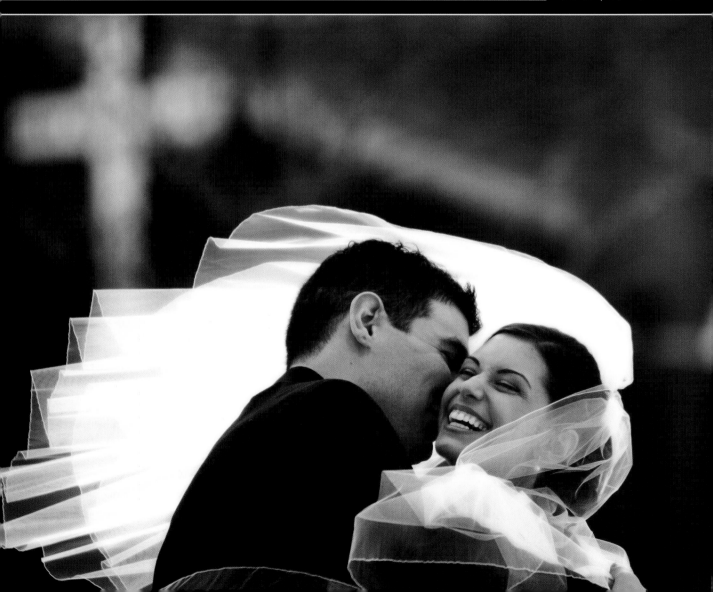

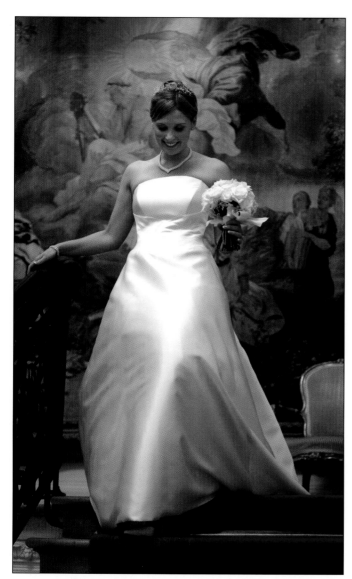

The 70–200mm or 80–200mm zoom is one of the most frequently used tools of the wedding photographer. When combined with the adjustable ISO speed of the DSLR, pictures can be made almost under any conditions. Dennis Orchard made this lovely image with a Canon EOS 1Ds and EF 70–200mm f/2.8L at $\frac{1}{60}$ second at f/2.8 at ISO 400 and the 70mm focal length.

a range of Kelvin degree (the color temperature of light) settings. Others use more photographer-friendly terms like "afternoon shade." In addition, virtually all of the cameras feature an automatic white-balance setting, which allows the camera to sense and determine the optimal white-balance setting. Most also include settings for fluorescent and incandescent lighting. Custom functions allow you to create your own unique white-balance settings to correspond to certain known shooting conditions or mixed light conditions. Obviously, the more flexibility you have in accurate white-balance

recording, the less color correction you will have to perform later in Photoshop. Some camera systems even offer a white-balance bracketing feature.

LENSES

Zoom Lenses. For today's digital photographer, one of the most popular lenses for all types of photography is the 80–200mm f/2.8 (Nikon) and 70–200mm f/2.8 (Nikon and Canon). These are very fast, functional lenses that offer a wide variety of useful focal lengths for many applications. This makes them particularly popular among wedding photographers, who find them useful for all phases of the ceremony and reception.

They are also internal focusing, meaning that autofocus is lightning fast and the lens does not change its physical length as it is focused. At the shortest range, 80mm (or 70mm), these lenses are perfect for full- and three-quarter-length portraits. At the long end, the 200mm setting is ideal for tightly cropped candid coverage or head-and-shoulders portraits. These zoom lenses also feature fixed maximum apertures, which do not change as the lens is zoomed. This is a prerequisite for any lens to be used in fast-changing conditions. Lenses with variable maximum apertures provide a cost savings but are not as functional nor as bright as a faster, fixed-aperture lenses.

Wide angle lenses are also popular—both fixed focal-length lenses and wide-angle zooms. Focal lengths from 17mm to 35mm are ideal for capturing atmosphere as well as for photographing larger groups.

Because digital lenses do not have to produce as wide a circle of coverage as lenses designed for full-frame chips, lens manufacturers have been able to come up with some splendid long-range zooms that cover wide-angle to telephoto focal lengths. Lenses like Canon's EF 28–300mm f/3.5–5.6L IS USM and EF 28–200mm f/3.5–5.6 USM are fast, lightweight, and

*M*ost seasoned professionals carry backups and double-backups—extra camera bodies, flash heads, transmitters, tons of batteries and cords, double the anticipated number of memory storage cards, and so on. In addition, if using AC-powered flash, extension cords, duct tape (for taping cords to the floor), power strips, flash tubes, and modeling lights need to be backed up. An emergency tool kit is also a good idea, as is a stepladder for photographing large groups or producing an overall shot.

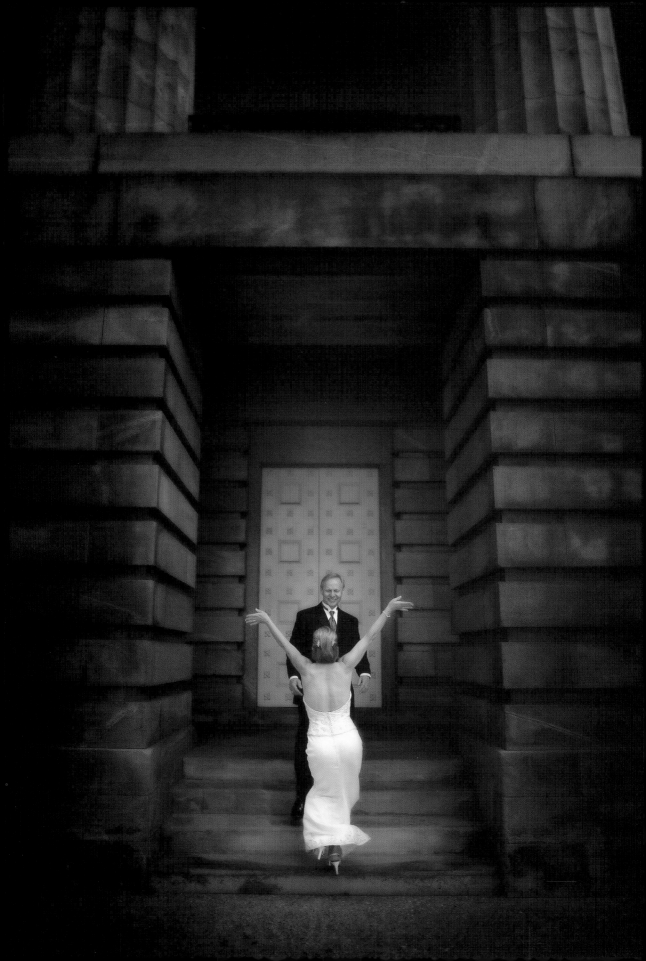

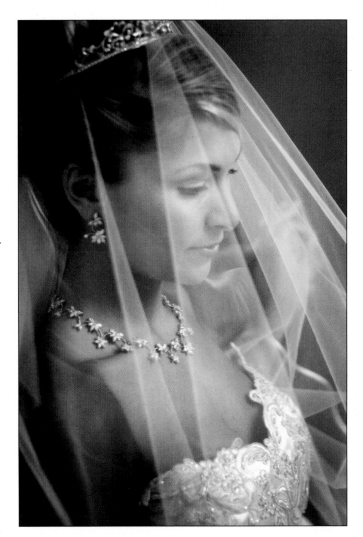

extremely versatile given the extreme range of focal lengths that are covered.

Prime Lenses. Fast, fixed focal-length (prime) lenses (f/2.8, f/2, f/1.8, f/1.4, f/1.2, etc.) will get lots of use, as they afford many more "available light" opportunities than slower speed lenses. Anytime you can avoid using flash, which naturally calls attention to itself, you should generally do so. Additionally, although modern zoom lenses, particularly those designed for digital SLRs, are extremely sharp, many photographers insist that a multipurpose lens cannot possibly be as sharp as a prime lens, which is optimized for use at a single focal length.

Mike Colón, a talented photographer from the San Diego area, uses prime lenses (not zooms) in his wedding coverage and shoots at wide-open apertures most of the time to minimize background distractions. He says, "The telephoto lens is my first choice, because it allows me to be far enough away to avoid drawing attention to myself but close enough to clearly capture the moment. Wide-angle lenses, however, are great for shooting from the hip. I can grab unexpected moments all around me without even looking through the lens."

Telephotos. Many photojournalists use ultra-fast telephotos, like the 300mm f/2.8 or f/3.5 lenses. These lenses, while heavy and often requiring a monopod for prolonged use, are ideal for working unobserved and they can help isolate some wonderful moments. Even more than the 80–200mm lens, the 300mm throws backgrounds beautifully out of focus. When used wide open at a relatively close camera-to-subject distance, the 300mm provides a delicately thin band of focus, which is ideal for isolating image details.

Another favorite lens is the 85mm (f/1.2 for Canon; f/1.4 or f/1.8 for Nikon), which is a short telephoto with exceptional sharpness. This lens gets used frequently because of its speed and ability to throw backgrounds out of focus, depending on the subject-to-camera distance. Because it produces exceptional image contrast, the difference between in-focus and out-of-focus areas appears much more distinct, thus exaggerating the effects of shooting wide open.

AF Technology. Autofocus, once unreliable and unpredictable, is now very advanced. Some cameras feature multiple-area autofocus so that you can, with a touch of a thumbwheel, change the AF sensor area to different areas of the viewfinder (the center or outer quadrants). This lets you "de-center" photos for more dynamic compositions. Once accustomed to quickly changing the AF area, this feature becomes an extension of the photographer's technique.

Since all but full-frame DSLRs have chip sizes smaller than 24x36mm (the size of a 35mm film frame), there is a magnification factor that changes the effective focal length of the lens. For instance, Nikon DSLRs have a 1.5X focal-length factor that makes a 50mm f/1.4 lens a 75mm f/1.4 lens—an ideal portrait lens.

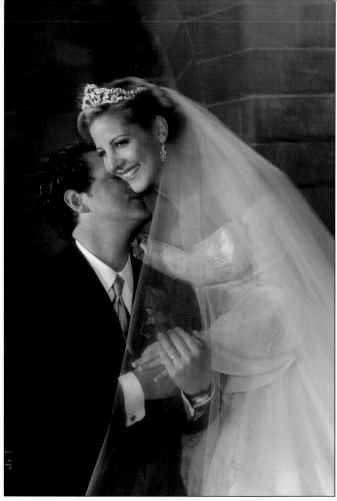

LEFT—Joe Photo made this exquisite detail with a Nikon D1X and 85mm f/1.4 lens at $^1/_{250}$ second at f/1.4 at ISO 800. Many wedding pros consider the prime focal length lens used wide open to be the ultimate in precision and excellence. RIGHT—Neil van Niekerk made this image with a Nikkor 50mm f/1.8 lens and a Nikon D2H. The focal-length factor transformed the 50mm lens into a 75mm lens. The image was recorded at $^1/_{13}$ second at f/5.0 with flash-fill. The smaller aperture was used to shoot at the optimum sharpness setting for this lens. File was recorded in NEF/RAW file mode. Credit: Neil van Niekerk for Milton Gil Photography.

Autofocus and moving subjects used to be an almost insurmountable problem. While you could predict the rate of movement and focus accordingly, the earliest AF systems could not. Now, however, almost all AF systems use a form of predictive autofocus, meaning that the system senses the speed and direction of the movement of the main subject and reacts by tracking the focus of the moving subject. This is an ideal feature for wedding photojournalism, where the action can be highly unpredictable.

A new addition to autofocus technology is dense multi-sensor area AF, in which an array of AF sensor zones (up to 45 at this writing) are densely packed within the frame, making precision focusing much faster and more accurate. These AF zones are user selectable or can all be activated at the same time for the fastest AF operation.

INCIDENT FLASHMETERS

A handheld incident flashmeter is essential for working indoors and out, but particularly crucial when mixing flash and daylight. It is also useful for determining lighting ratios. Flashmeters are invaluable when using multiple strobes and when trying to determine the overall evenness of lighting in a large-size room. Flashmeters are also ambient incident light meters, meaning that they measure the light falling on them and not light reflected from a source or object as the in-camera meter does.

LIGHTING

On-Camera Flash. Even at weddings, on-camera flash is used sparingly these days because of its flat, harsh light. As an alternative, many photographers use on-camera flash brackets, which position the flash over and away from the lens, reducing red-eye and dropping the

harsh shadows behind the subjects—a slightly more flattering light.

On-camera flash is, however, often used outdoors, especially with TTL-balanced flash exposure systems. With such systems, you can adjust the flash output for various fill-in ratios, thus producing consistent exposures. In these situations, the on-camera flash is most frequently used to fill in the shadows caused by the daylight, or to match the ambient light output, providing direction to the light.

Bounce-Flash Devices. Many photographers use their on-camera flash in bounce-flash mode. A problem, however, with bounce flash is that it produces an *overhead* soft light. With high ceilings, the problem is even worse—the light source, while soft, is almost *directly* overhead. There are a number of devices on the market that solve this problem. For example, the Lumiquest ProMax system allows 80 percent of the flash's illumination to bounce off the ceiling while 20 percent is redirected forward as fill light. The system also includes interchangeable white, gold, and silver inserts, as well as a removable frosted diffusion screen. This same company also offers devices like the Pocket Bouncer, which enlarges and redirects light at a 90-degree angle from the flash to soften the quality of light

TOP—Joe Photo used a "cloudy" white balance setting on his Nikon D1X and fill flash on camera to keep the colors, particularly the wedding gown) accurate as well as to add a bit of sparkle to their eyes. He adjusted the hue slightly in processing the image to clean up the whites. BOTTOM—Tom Muñoz made this lovely image with a combination of window light and bounce flash. The bounce flash—off the ceiling and far wall—helps to fill in the shadows and even out the overall balance of the window light.

LEFT—Tom Muñoz created this exquisite image using window light, incandescent room light, and studio strobe (positioned out of view in the camera-right corner of the room) bounced onto the ceiling. The strobe provided a beautiful edge light on the bride and her bridesmaid. RIGHT—Here, Tom Muñoz captured all the ambiance of the reception. He used a Canon EOS 1DS and 16mm Canon lens with off-camera diffused flash placed high and to the left of the couple. He exposed the image for $^1/_{15}$ second at f/2.8 so that the room lighting would record normally. This is commonly called dragging the shutter.

and distribute it over a wider area. While no exposure compensation is necessary when using TTL-flash exposure systems, operating distances are somewhat reduced. With both systems, light loss is approximately $1^1/_3$ stops, however with the ProMax system, using the gold or silver inserts will lower the light loss to approximately $^2/_3$ stop.

Barebulb Flash. Barebulb flash units with an upright mounted flash tube sealed for protection in a plastic housing are one of the most frequently used

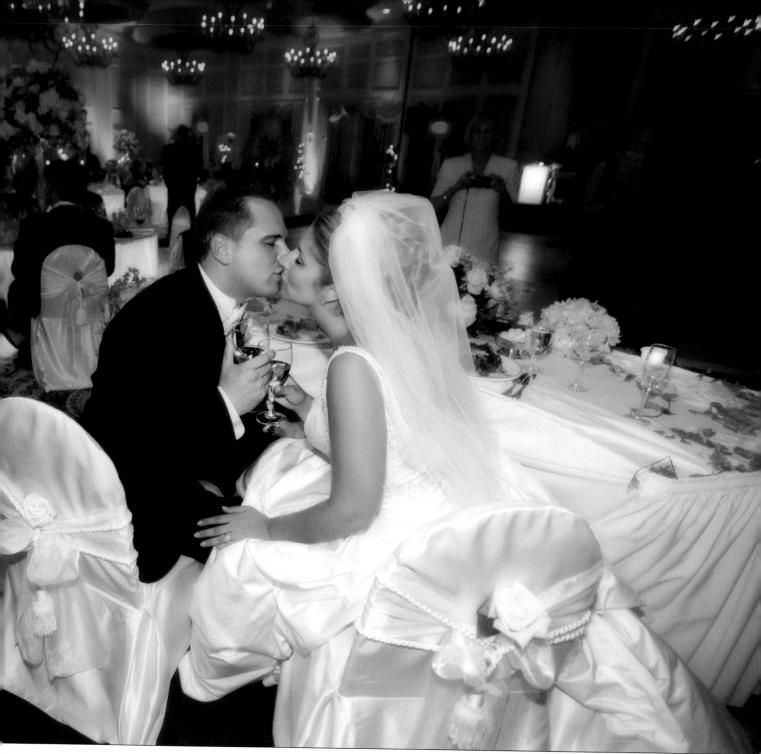

handheld flash units at weddings. This is because the 360-degree light coverage means that you can use all of your wide-angle lenses. One popular unit is the Dyna-Lite NE-1 flash, which has a 1000 watt-second pencil-style flash tube. This great location tool is compact and lightweight and can literally fit in your pocket.

These light sources act more like large point-source lights than a small portable flashes. Light falloff is less than with other handheld units, and they are ideal for flash-fill situations, particularly outdoors. These are pre-dominantly manual flash units, meaning that you must adjust their intensity by changing the flash-to-subject distance or by adjusting the flash-output setting. At weddings, many photographers mount a sequence of barebulb flash units on light stands (using ball-head adapters to fine tune the position the light) for doing candids on the dance floor.

Studio Flash System. You may find it useful to have a number of studio flash heads with power packs and umbrellas. You can set these up for formals or tape the

Light stands are an important part of location lighting. You should use heavy-duty stands, tape them firmly to the floor, and try to hide them in corners of the room so they don't blast direct light into your lens. The light stands should be extend to a height of 12–15 feet. Lights should be aimed down and "feathered," so their beams cross, making the lighting as even as possible. The lights can be set to backlight the people at the reception and an on-camera flash used to trigger the system.

Umbrellas. Studio flash units can be used with umbrellas for lighting large areas of a room. Be sure, however, to focus the umbrella—adjusting the cone of light that bounces into and out of the umbrella surface by moving the umbrella closer to and farther away from the light source. The ideal position is when the light fills the umbrella but does not exceed its perimeter. Focusing the umbrella also helps eliminate hot spots as well as maximizing light output.

Reflectors. When photographing by window light or outdoors, it is a good idea to have a selection of white, silver, gold, and black reflectors. Most photographers opt for the circular disks, called Lite Discs, which unfold to produce a large size reflector. They are particularly valuable when making portraits by available light. An assistant is useful to focus the light of the reflector on the faces of your subjects.

light stands to the floor and use them to light large areas. Either way, you'll need enough power (at least 50 to 100 watt-seconds per head) to light large areas.

The most popular studio flash is the monolight unit, which has a self-contained power pack and, usually, an on-board photo cell to trigger it to fire when it senses a flash burst. All you need is an electrical outlet and the flash can be positioned anywhere. Be sure to take along plenty of gaffers' tape and extension cords. Tape everything in position securely to prevent accidents.

One such monolight preferred by wedding photographers is the Dyna-Lite Uni 400JR, a 3.5-pound compact 400 watt-second unit that can be plugged into an AC outlet or used with the Dyna-Lite Jackrabbit high-voltage battery pack. The strobe features variable power output and recycle times, a full tracking quartz modeling light, and a built-in slave.

REMOTE TRIGGERING DEVICES

If using multiple flash units to light the reception or dance floor, some type of remote triggering device will be needed to sync all the flash units at the instant of exposure. There are a variety of these devices available, but by far the most reliable is the radio remote triggering device. These devices use a radio signal transmitted when you press the shutter release and received by individual receivers mounted to each flash.

Radio remotes transmit signals in either digital or analog form. Digital systems, like the Pocket Wizard Plus, are state of the art. Complex 16-bit digitally coded radio signals deliver a unique code, ensuring the receiver cannot be triggered or "locked up" by other radio noise. The built-in microprocessor guarantees consistent sync speeds even under the worst conditions. Some photographers use a separate transmitter for each camera in use (for instance, an assistant's camera) as well as a separate transmitter for the handheld flash meter, allowing the photographer to take remote flash readings from anywhere in the room.

TWO-WAY RADIOS

When using assistants and slaved flash units, it is a great idea to be in constant contact with your staff. Motorola makes a wide range of two-way radios with Bluetooth-enabled wireless headsets that allow you to be in constant contact with your assistants. Such communication is invaluable at large weddings when it may take valuable time for you to first find your assistant and then communicate with him or her. These devices make it simple to give your assistant an order—"Check the cables on the strobe in the southwest corner of the room, it's not firing," or, "Bring me a new CF card, this one's almost done." If an assistant is downloading images, you might also get valuable feedback from them as they see your finished images. The bigger the wedding and the more people you bring to the job, the more a two-way radio system becomes important.

WIFI TECHNOLOGY

With a wireless WiFi transmitter, it's possible to transmit images directly from the camera over a wireless LAN (local area network). Nikon's Wireless Transmitter WT-2A allows photographers to not only transmit images over a Wi-Fi network, but also allows wireless remote control of the camera over a Wi-Fi network from a computer running Nikon Capture software. Photographers can position the camera in places that may be inaccessible or restricted to photographers, and wirelessly adjust settings, trigger the camera, and instantly retrieve the images over the LAN. Locations such as the Space Shuttle launches, where security is unforgiving, can now be photographed remotely with greater control and instant image retrieval.

The applications of this technology are limitless. The latest versions of this software feature drastically improved transmission times and highly refined security protocols, making it nearly impossible for someone to intercept the transmission.

A single large umbrella was used to create on-location portrait light so that the photographer could create a formal portrait with portrait lighting in the church following the ceremony. Often, a hand-held reflector is used close to the shadow side of the face to raise the shadow intensity. The main light was positioned to the left and above camera position. Photograph by Claude Jodoin.

5.
DIGITAL
WORKING
TECHNIQUES

Working with digital files is very much different than working with film. For one thing, the exposure latitude, particularly when it comes to overexposure, is almost nonexistent. Some photographers liken shooting digital, especially JPEGs, to shooting transparency film: it is unforgiving in terms of its exposure lati-

Marc Weisberg created this quirky but delightful image in RAW mode and saved the file to an Adobe Digital Negative (DNG) file. The image was made with a Canon EOS 20D and 28–70mm zoom at $1/125$ second at f/9 at ISO 200. The DNG settings included change of tint, exposure, white balance; increased sharpening and contrast; and slight color noise reduction.

tude. The up side of this seeming flaw in the process is that greater care taken in creating a proper exposure will only make you a better photographer. But for those photographers who are used to ± 2 stops of over- and underexposure latitude, this is a different ballgame altogether.

Proper exposure is essential in that it determines the dynamic range of tones and the overall quality of the image—in fact, it is one of the key factors determining the quality of the final output from your digital file. Underexposed digital files tend to have an excessive amount of noise; overexposed files lack detail in the highlights.

METERING

The preferred type of meter is the handheld digital incident-light meter, which measures light in small units—tenths of a stop. This type of meter does not measure the reflectance of the subjects, but rather it measures the amount of light falling on the scene. Simply stand where you want your subjects to be, point the meter's dome (hemisphere) directly at the camera lens, and take a reading. This type of meter yields extremely consistent results, because it is less likely to be influenced by highly reflective or light-absorbing surfaces, like white dresses or black tuxedos.

There is another school of thought on where to point an incident meter. Some photographers insist that one must point the meter at the light source and not at the camera lens. Sometimes there is no difference in the readings, but sometimes there is—up to $\frac{1}{2}$ stop difference, which can make a difference in digital exposures. It is advisable to get into the habit of metering in both ways. Then make two test exposures at the different settings and view them on the LCD to see which is more accurate.

As noted above, it is advisable to run periodic checks on your meter, if you base the majority of your exposures on its data. If your incident meter is also a flashmeter, you should check it against a second meter to verify its accuracy. Like all mechanical instruments, meters can become temporarily out of whack and need periodic adjustment.

With advances in multi-pattern metering, in-camera metering has been vastly improved, however, one must still recognize those situations when a predominance of

If you are using an incident meter but can't physically get to your subject position to take a reading, you can meter the light at your location—provided it is the same as the lighting at the subject position.

light or dark tones will unduly influence the meter reading and subsequent exposure.

EVALUATING EXPOSURE

There are two ways of evaluating exposure of the captured image: by judging the histogram and by evaluating the image on the camera's LCD screen.

Histograms. By far, the most reliable way to judge exposure is using the histogram. This is a graph that indicates the number of pixels that exist for each brightness level. Histograms are scene-dependent. In other words, the number of pixels for each brightness level will directly relate to the subject brightness and how it is illuminated and captured.

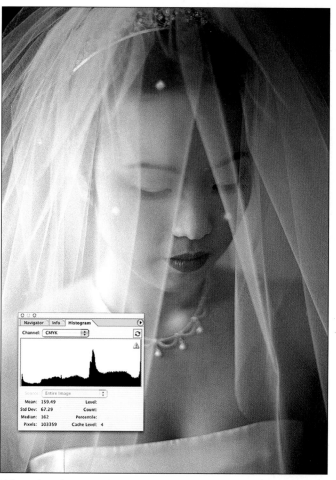

When the photographer, Ann Hamilton, made a vignetted version of the high-key image (page 58) with more midtones and shadows, the histogram changed. It now covers the full length of the tonal scale.

Evaluating an LCD Image. With higher resolution LCDs, larger screens, and more functions in the playback mode of the camera, you can often use the LCD screen to evaluate images (although the changing light conditions found at most wedding shoots can sometimes make this less reliable than in other shooting circumstances).

Most professional DSLRs let you zoom and scroll across an image to evaluate details. This will tell you if the image is sharp or not. Also, you can set certain playback presets to automatically indicate problems like "clipped" highlights. These are regions of the image in which no detail is present.

WHITE BALANCE

White balance is the camera's ability to correct color when shooting under a variety of different lighting conditions, including daylight, strobe, tungsten, fluorescent, and mixed lighting. Choosing the right white-balance setting is very important if you are shooting highest-quality JPEG files. It is less important when shooting in RAW file mode, since these files contain more

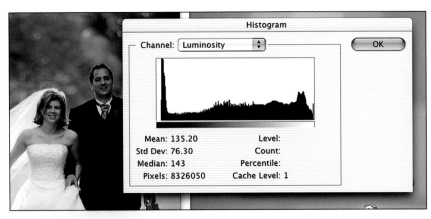

In a normally exposed image with an average range of highlights and shadows, the histogram will have the highest number of pixels in the midtones, as is seen here in this image by David Williams.

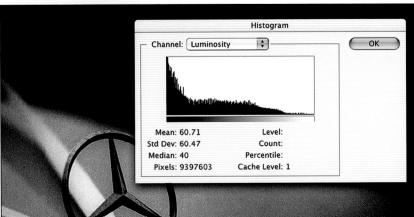

A low-key image, like this one made by Mercury Megaloudis of a Mercedes decked out with ribbons for the wedding day, has its data points concentrated in the shadow area of the histogram (the left side of the graph).

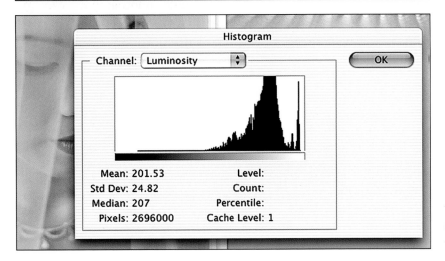

In a high-key image, such as this one by San Francisco wedding photographer, Ann Hamilton, the histogram has most of its image detail concentrated in the highlights (the right side of the histogram).

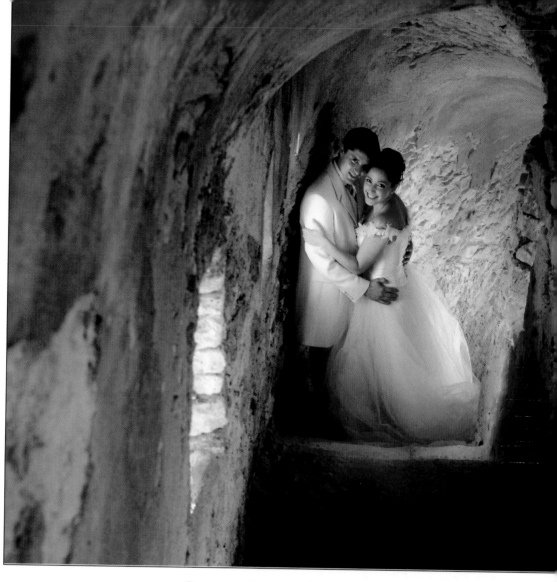

In a scene such as this one, illuminated by both daylight and incandescent lights, a custom white balance is a necessity. Sometimes trial and error (changing the white balance and viewing the LCD test exposure) can yield good results. Here the bias is more toward a true incandescent setting. Photograph by Bruno Mayor.

data than the compressed JPEG files and are easily remedied later.

DSLRs have a variety of white-balance presets, such as daylight, incandescent, and fluorescent. Some also allow the photographer to dial in specific color temperatures in Kelvin degrees. These are often related to a time of day. For example, a pre-sunrise shoot might call for a white-balance setting of 2000°K, while heavy overcast lighting might call for a white-balance setting of 8000°K.

Most DSLRs also have a provision for creating a custom white-balance setting, which is essential in mixed-light conditions, most indoor available-light situations, and with studio strobes. Many photographers like to take a custom white-balance reading of any scene where they are unsure of the lighting mix. By selecting a white area in the scene and neutralizing it with the custom white balance, you can be assured of a fairly accurate color rendition.

OTHER CAMERA SETTINGS

Sharpening. In your camera's presets or in your RAW file processing software, you will have a setting for image sharpening. You should choose none or low sharpening. The reason for this is that sharpening can eliminate data in an image and cause color shifts. Sharpening is best done after the other post-processing effects are complete.

Contrast. Contrast should be set to the lowest possible contrast setting.

Noise. Noise is a condition, not unlike excessive grain, that occurs when stray electronic information affects the sensor sites. It is made worse by heat, long exposures, and high ISOs. Noise shows up more in dark areas making evening and night photography problematic with digital capture. It is worth noting because it is one of the areas where digital capture is quite different from film capture. Some cameras have in their camera setup files noise-reduction filters designed for reducing the effects of noise in long exposures. Also, in RAW file processing programs noise can be minimized or eliminated with the use of several control settings.

Metadata. DSLRs give you the option of tagging your digital image files with data, which often includes date and time, as well as camera settings. Many photographers don't even know where to find this information. In Photoshop, if you go to File>File Info you will see a

\mathcal{F}ujifilm, the company that makes the Frontier digital printer, one of the most widely used lab printers, recommends that photographers "Stay inside the sRGB color space by capturing and working in the sRGB mode. If the photographer's camera allows the 'tagging' of ICC profiles other than sRGB, we recommend selecting the sRGB option for file creation. The native color space of many professional digital cameras is sRGB, and Fujifilm recommends the sRGB option as the working space for file manipulation when using Adobe Photoshop along with a fully calibrated monitor. End users/photographers who alter the color space of the original file by using a space other than sRGB, without being fully ICC [color profiles for devices, including cameras, monitors, and printers] aware, are actually damaging the files that they submit to their labs."

Reading between the lines, the reason Fuji is so adamant about the use of the sRBG color space is that their printers also operate in that color space. Lab operators would have to convert the files from Adobe 1998 RGB to sRGB, meaning one more step in the operation, but more important, the photographer would expect a certain rendition based on working in a wider gamut color space and perhaps be disappointed in seeing the finished lab results.

range of data including caption and ID information. If you then go to EXIF data in the pull-down menu, you will see all of the data that the camera automatically tags with the file. Depending on camera model, various other information can be written to the EXIF file, which can be useful for either the client or lab. You can also add your copyright symbol (©) and notice either from within Photoshop or from your camera's metadata setup files. Adobe Photoshop supports the information standard developed by the Newspaper Association of America (NAA) and the International Press Telecommunications Council (IPTC) to identify transmitted text and images. This standard includes entries for captions, keywords, categories, credits, and origins from Photoshop.

REFORMAT YOUR CARDS
After you backup your source files, it's a good idea to reformat your CF cards. It isn't enough to simply delete the images, because extraneous data may remain on the card causing data interference. After reformatting, you're ready to use the CF card again.

Never format your cards prior to backing up your files to at least two sources. Some photographers shoot an entire job on a series of cards and take them back to

the studio prior to performing any backup. Others refuse to fill an entire card at any time; instead opting to download, back up, and reformat cards directly during a shoot. This is a question of preference and security. Many photographers who shoot with a team of shooters train their assistants to perform these operations to guarantee the images are safe and in hand before anyone leaves the wedding.

COLOR SPACE
Many DSLRs allow you to shoot in either Adobe RGB 1998 or sRGB color space. There is considerable confusion over which of these is "right." Adobe RGB 1998 is a wider-gamut color space than sRGB, so photographers reason that they should choose this in order to capture the maximum range of color. Professional digital imaging labs, however, use the sRGB color space for their digital printers. Therefore, professional photographers working in Adobe 1998 RGB will be somewhat disheartened when their files are reconfigured and output in the narrower color sRGB space.

As a compromise, many photographers who work in the JPEG format use the Adobe 1998 RGB color space all the time—right up to the point that their image files are sent to a printer or out to the lab for printing. The reasoning is that since the color gamut is wider with Adobe 1998 RGB, more control is afforded. Claude Jodoin is one such photographer. He likes to get the maximum amount of color information in the original file, edit the file in the same color space for maximum control of the image subtleties, then convert the image for output.

Is there ever a need for other color spaces? Yes. It depends on your particular workflow. For example, all the images you see in this book have been converted from their native sRGB or Adobe 1998 RGB color space to the CMYK color space for photomechanical printing. As a general preference, I prefer images from photographers be in the Adobe 1998 RGB color space as they seem to convert more naturally to CMYK.

RAW FILE FORMAT
What is RAW Mode? RAW is a general term for a variety of proprietary file formats such as Nikon's .NEF, Canon's .CRW and .CR2, and Olympus' .ORF. While there are many different encoding strategies, in each

case the file records the raw, unprocessed image-sensor data. RAW files consist of the image pixels themselves and the image metadata, which contains a variety of information about how the image was recorded. This is needed by RAW converters in order to process the RAW capture into an RGB image.

RAW File Converters. Because they include some additional metadata, RAW format image files must be converted by a RAW image converter before they can be utilized. These converters process the white balance, colorimetric data (the assigning of red, green, and blue to each pixel), Gamma correction, noise reduction, antialiasing (to avoid color artifacts), and sharpening. However, different converters use different algorithms; some process the tones with less contrast in order to provide editing maneuverability, others will increase the contrast of the file to achieve a more film-like rendition, for example. As a result, the same image may look different when processed by different RAW converter engines.

How JPEG Differs from RAW. When you shoot JPEG, a built-in RAW converter in the camera carries out all of the same tasks as described above to turn the RAW capture into a color image, then compresses it using JPEG compression. Some camera systems allow you to set parameters for this JPEG conversion— usually, a choice of sRGB or Adobe RGB 1998 color space, a sharpness setting, and a curve or contrast setting.

JPEG. JPEGs offer fairly limited editing ability, since the mode applies heavy compression to the color data. In the typical conversion process, the JPEG compression will discard roughly a stop of usable dynamic range, and you have very little control over what information gets discarded.

In some ways, shooting JPEGs is like shooting transparency film, while shooting RAW is more like shooting color-negative film. With JPEG, as with transparency film, you need to get everything right in the camera because there's very little you can do to change it later. Shooting RAW mode provides considerable latitude in determining the tonal rendition and also offers much greater freedom in interpreting the color balance and saturation.

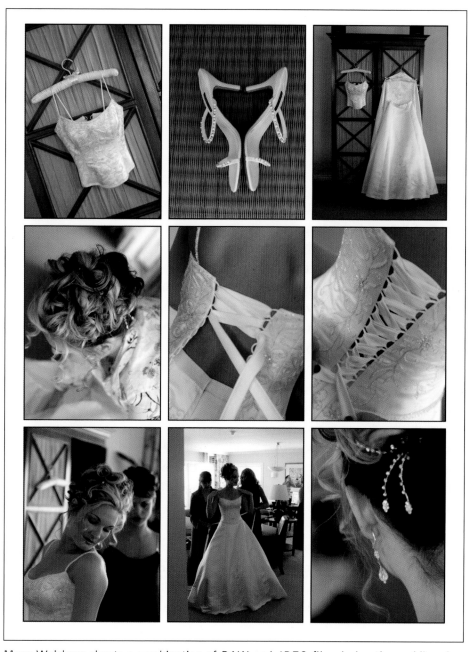

Marc Weisberg shoots a combination of RAW and JPEG files during the wedding day. He chooses RAW files for complex images, like those including mixed lighting or long exposures that might include a lot of image noise. Yet the JPEG mode is ideal for working quickly as in these images of the bride getting ready.

To resolve the disparity between RAW file formats, Adobe Systems introduced an open RAW file format, appropriately named the Digital Negative (DNG) format. Adobe is pushing digital camera manufacturers and imaging software developers to adopt the new DNG format. Unlike the numerous proprietary RAW formats out there, the DNG format was designed with enough flexibility built in to incorporate all the image data and metadata that any digital camera might generate. Proprietary RAW format images that are pulled into Photoshop can be saved to the new DNG file format with all the RAW characteristics being retained. DNG Save options include the ability to embed the original RAW file in the DNG file, to convert the image data to an interpolated format, and to vary the compression ratio of the accompanying JPEG preview image.

So why do many photographers still choose to shoot JPEGs? First, shooting in JPEG mode creates smaller files, so you can save more images per CF card or storage device. Second, compared to shooting RAW files, JPEGs do not take nearly as long to write to memory. Both factors allow you to work much faster—a clear advantage in some situations. If you shoot JPEGs, selecting the JPEG Fine mode (sometimes called JPEG Highest Quality) will apply the least compression and, therefore, produce the best possible files.

JPEG is a "lossy" format, meaning that images are subject to degradation by repeated opening and closing of the file. Therefore, most photographers who shoot in JPEG mode save the file as a JPEG copy each time they work on it or save it to the TIFF format. TIFF is a "lossless" format, meaning that images can be saved again and again without further degradation.

RAW. When you shoot in RAW mode, you get unparalleled control over the interpretation of the image. The only in-camera settings that have an effect on the captured pixels are ISO speed, shutter speed, and aperture setting. Everything else is under your control when you convert the RAW file—you can reinterpret the white balance, the colorimetric rendering, the tonal response, and the detail rendition (sharpening and noise reduction) with complete flexibility. Within limits (which vary from one RAW converter to another), you can even reinterpret the exposure compensation.

While RAW files offer the benefit of retaining the highest amount of image data from the original capture, they also take longer to write to the storage media and drastically reduce the number of files you can capture

on a single CF card or microdrive because of their increased file size. Although the cost of media is coming down, the time it takes to record the information is not necessarily getting much faster. If the kind of shooting you do requires fast burst rates and lots of image files—exactly what wedding photographers experience—then RAW capture may not be your best choice.

Working in Adobe Camera RAW. Adobe Camera RAW, Adobe's RAW file converter, is a sophisticated application within Photoshop that lets you far exceed the capabilities of what you can do to a JPEG file in the camera. For instance, by changing the color space from Adobe RGB 1998, a wide gamut color space, to ProPhoto RGB, an even wider gamut color space, it allows you to interpolate the color data in the RAW file upward.

Using the Advanced Settings in Adobe Camera RAW, you can adjust many of the image parameters with much more power and discrimination than you can in the camera. For instance, under the Detail menu, you can adjust image sharpness, luminance smoothing, and color noise reduction (luminance smoothing reduces grayscale noise, while color noise reduction reduces chroma noise). In the Adjust menu you can control white balance, exposure, shadow density, brightness, contrast, and color saturation. The Lens menu lets you adjust lens parameters that affect digital cameras, such as chromatic aberration and vignetting. These controls exist to allow you to make up for certain optical deficiencies in lenses, but can also be used for creative

In the image shown here, the file was processed in Adobe Camera RAW. The number of pixels was quadrupled—from the chip's native resolution of 2000x3000 pixels up to roughly 4000x6000 pixels.

TOP—Bridge is a sophisticated application that is a part of Adobe CS2. It allows you to work across applications and perform batch-processing operations. BOTTOM—Apple's Aperture is an all-in-one post-production tool that provides everything photographers need for RAW file processing. Aperture offers an advanced and incredibly fast RAW workflow that makes working with a camera's RAW images as easy as working with JPEGs. Built from the ground up for pros, Aperture features powerful compare and select tools, non-destructive image processing, color-managed printing, and custom web and book publishing. RAW images are maintained natively throughout Aperture without any intermediate conversion process, and can be retouched with exceptional results using a suite of tools designed especially for photographers.

effects, as well—especially the vignetting control, which either adds or subtracts image density in the corners of the image. In the Calibrate menu, you can adjust the hue and saturation of each channel (RGB), as well as shadow tint. (Shadow tint is particularly useful, as it provides the basis for color correction of images with people in them. In traditional color printing, color correction is done to neutralize the tint in the shadows of the face and body, so they are gray or neutral. With shadow tint control, you isolate the shadows from the rest of the image so that you can neutralize the shadows, while leaving a warm tone, for example, in the facial highlights.)

In Photoshop CS2, Adobe Camera RAW combines with the modified file browser, called Bridge, to allow you to group a number of like files and correct them all the same way at the same time. This capability is a modified or selective batch processing that is much more useful than former means of batch processing. Plus you can continue working while the files process.]

6.
WORKFLOW

*H*ere are two basic workflow descriptions. The first is a wedding workflow by Michael Ayers designed around JPEGs and incorporates a lot of different features, including uploading to an Internet site for extended sales and proofing.

The second is a RAW file wedding workflow by Neil Van Niekerk designed around using the RAW file's rich data to enhance each file by batch processing. Van Niekerk hands his final images off to a lab for printing as JPEGs.

There are many other workflows around, almost as many as photographers doing wedding photography, but these two are different enough to provide some good insight into the organization and thinking that went into them.

BASIC JPEG WORKFLOW

This example of a basic workflow comes courtesy of Michael Ayers, an award-winning photographer from Ohio. It assumes that the files were captured as highest quality JPEGs. Ayers' workflow is a good model because it includes printed proofs, a virtual proof album on CD, and uploading low-resolution JPEGs to a website for general viewing and purchase by guests and relatives.

Uploading. After the images have been captured, the CF cards or removable media are assembled and the process of uploading the JPEG files to your computer's hard drive can begin. FireWire or USB 2.0 card readers are recommended for this purpose, as their connectivity speed allows you to upload large numbers of image files quickly. Files should be uploaded to folders, which can be broken down according to chronology or function—1. Pre-Wedding, 2. Wedding, 3. Reception, and so forth. Some photographers name these file folders 1000, 2000, 3000, etc., so that files named with those prefixes will be instantly recognizable as "Wedding," "Reception," and so forth.

File Backup. All image files should be backed up onto CD-ROMs at this point; these are your source files—your originals. Many photographers use DVDs, as their capacity is much greater and all of the folders can be copied onto one disk. You may also consider a portable hard drive as a suitable backup device.

Edit and Adjust. Michael Ayers always shoots extra copies of some images, especially groups, to insure that he has captured everyone looking their best. At this stage, he goes into the computer browser (Microsoft XP filmstrip browser, Adobe Photoshop file browser, Photoshop CS2's Bridge) to edit the images. Any poorly exposed images or duplicates are deleted at this point. Some exposures may need color adjustment or contrast changes. At this point in the process, Ayers will adjust these images in Photoshop's Levels or Curves. He will also fix obvious problems, removing EXIT signs, adjusting odd compositions, etc.

Image Manipulation. It's at this point that Ayers begins to "play" with the images in Photoshop, using various plug-ins and actions to creatively alter the images. Some will be turned into monochrome or sepia-tone images, some will get selective coloring. The full gamut of creative effects is open to him.

Rename. To this point, most images have been saved as high quality JPEGs; Ayers has not saved the images more than once, so there's no loss of quality from the originals. If he plans on manipulating an image further, he saves it as a TIFF file. When all images are finished and in order, he uses either Photoshop or CompuPic Pro to do a Batch Rename on all the files. His system calls for a three-digit serial number plus the extension, for example: 001.JPG, 002.JPG, 003.JPG.

Some photographers choose to rotate the images at this point for proper orientation. Programs such as ACDSee, EZViewer, or Thumbs Plus are powerful browsers used in conjunction with Photoshop. You can use them to rotate a display of images.

Copy Again. Once the Photoshop work is complete, Ayers makes another set of copies of the finished files in their folders. This time he makes the copies to an external portable hard drive, using either USB 2.0 or Firewire connectivity for fastest transfer.

Ayers recommends disconnecting this hard drive from the computer and storing it unplugged in another location.

Proof Setup and Printing. For proofing, Ayers' studio provides pages placed into a 10x13-inch General Products album binder. These 10x13-inch proof pages are printed "nine-up" (three rows of three), so each image is about 3x4 inches with a border. He creates these using the Picture Index function in CompuPic Pro, which takes only a few minutes. There are other programs that will create similar proofs, including Photoshop (File>Automate>Contact Sheet II). Ayers sometimes prints these pages out on his Fujifilm PG 4500 printer, otherwise he sends them to his lab.

FlipAlbum. FlipAlbum Pro is a program used to create attractive digital proof books on CD-ROM. Ayers first copies all of the finished images in his wedding folders into a folder called the FlipAlbum folder. The images will become the basis for the virtual proof book made with the FlipAlbum Professional software. Having a complete but separate folder for these images

Special indexes and custom thumb tabs provide quick navigation of all images in a FlipAlbum with just a click. Customers can also look at large amounts of photographs using the table of contents before placing orders with the studio.

images. He then opens them in Photoshop and batch rotates them using an easy-to-create Photoshop action, so all are properly oriented on screen. Every one of these photographs is now oriented correctly and will be used not only for the FlipAlbum CD-Rs but also as the images to upload to the Eventpix.com website later in the process.

Special features of FlipAlbum include the ability to show panoramas, an index, and table of contents, and security options like password protection, expiration date, and anti-copy/print functions. Ayers generally builds several of these CD-Rs so that the couple and significant family members can have them to choose images and place orders.

For weddings and other special events, the page format can be customized for a beautiful, less institutional appearance. The pages turn forward and backward by clicking on the pages.

Uploading to the Internet. There are a number of Internet companies that will display your wedding photos online and even handle online ordering and fulfillment for you. Ayers uses Eventpix.com, because he says it is fast and secure for his clients to use. He finds it has resulted in many additional orders per wedding from people who would normally never have even viewed the event's originals! He usually uploads about 150 images and leaves them up for two months.

Consolidate Orders. All orders received online, by fax, by phone, or from the couple are consolidated into a big print order in a separate folder for Ayers' lab using Fujifilm's Studiomaster Pro software. Studiomaster Pro lets a customer build an order that goes directly to your lab and provides all the tools you need to create a dazzling studio preview for your clients. It also allows cropping, resizing, and retouching to be done to your images before printing.

Michael Ayers uploads every wedding to Eventpix.com because it adds to his total sales from friends and relatives who attended the wedding or who were unable to attend the wedding.

is a necessary step and a safeguard against damaging or changing any originals from the wedding folder.

All images in this folder get resized to 1200x800 pixels. Ayers uses Photoshop's Batch controls (File> Automate>Batch) and saves these images as low-quality JPEGs at the "3" quality setting—good enough for screen viewing. This ensures the FlipAlbums will run at peak speed and require little disk space on a CD-R.

At this point, Ayers goes through the images in the FlipAlbum folder, selecting and highlighting the vertical

Later, album orders are also arranged into orders and even "Smart Pages" using this software. Ayers raves about this workflow package, claiming it is quickly becoming the key to his studio's productivity. (*Note:* Kodak's comparable software, Pro Shots, is currently in its sixth generation and is also quite popular with many labs and photographers.)

Thumbnails. Contact Sheet II in Photoshop allows Ayers to print out tiny thumbnails of all of the couple's favorites, which are now in a folder called "Album Choices." He prints these little images on adhesive-backed paper and cuts them up into little stickers. He says of this method, "I've used many album design software programs in the past and this manual option gives me greater flexibility with my creative pages."

Album Layout. Ayers schedules an appointment for the couple to review the album choices, then they stick the thumbnails down onto squares, which represent the pages of the album—almost like playing Scrabble! The couple usually has a lot of input as he shows them his ideas. The album will be built exactly as they have envisioned it.

Retouching. With all the orders and albums ready to be printed, Ayers goes through each photograph one last time to check color and fix any problem, such as blemishes, glasses glare, stray hairs, shiny faces, and even "blinks" are corrected here, if possible.

Ordering. Ayers' orders from Studiomaster Pro are sent directly to his lab using CDs or FTP (File Transfer Protocol). Most orders are processed and returned in just a few days without rush-service charges. All images are printed on a Fujifilm Frontier on Fuji Crystal Archive Paper.

Album Ordering. Ayers then faxes the order for the album cover, mats, inserts, and panorama pages to General Products, a Chicago album company. This is another area that differs greatly among photographers; Ayers prefers mats and inserts, other photographers prefer digitally generated, hand-bound albums.

Print Sorting. When prints come back from the lab, the quality and quantity are checked. Then the prints are separated with each person's orders. The album prints are put in order with the layout forms so they can be placed in mats quickly. Missing or damaged prints are noted so they can be sent back with the next order to the lab. All client orders are placed on the studio's work-in-progress shelves in the production room.

Folders and Mounting. Ayers' studio uses folders for 5x7-inch and smaller prints, which come from General Products. Larger individual prints are mounted on premium-quality mount board. Ayers believes that presentation is very important if you charge a premium for your work, so get the best photo mounts available for reasonable prices! All album prints are placed in General Products mats and bonded permanently into the inserts, which are placed into the album cover.

Shipping. Many of Ayers' wedding clients live out of town. If they are local, though, he sets up a special time to present their album and deliver other related orders, as well. Otherwise, he'll ship the finished products in specially lined boxes.

Archiving. Finally, the entire set of folders is archived to DVD. Michael always makes sure everyone

Michael Ayers shoots in the more traditional style of wedding photography but does a beautiful job. This studio formal of the bride shows off her beautiful rings and displays elegant posing technique.

Michael Ayers is a superb craftsman, making this wonderful image that incorporates the church interior and ceremony, as well as the shiny marble floor of the church. Image made with a Fuji FinePix S3 Pro.

is finished ordering first, and he also tests this final DVD on another computer to make sure that it operates perfectly. He is now ready to delete this set of folders from the hard drive to make room for new weddings. He stores final DVDs in archival-quality containers (like jewel cases) in a cool, dark, and safe place.

BASIC RAW + JPEG FILE WORKFLOW

Neil van Niekerk of Planet Neil (www.planetneil.com), a unique web site for digital shooters, has some terrific advice for a RAW file workflow. Neil shoots nearly exclusively in the RAW file format because of the adjustment flexibility and because RAW is much more forgiv-

ing in terms of exposure and color balance than the JPEG format. Another appealing aspect of the RAW format is that with JPEGs (as a result of the lossy compression) you'd have to come up with a system where you keep multiple copies and multiple backups so that you don't overwrite your originals. With RAW, you always have your originals to work on and change with no degradation.

Neil's digital workflow is structured around his work as a wedding photographer. He photographs between one and three weddings a weekend, and he shoots between 800 and 1200 images at each wedding in RAW file format. His digital workflow is aimed at getting the best possible image in a reasonable amount of time. Neil's workflow also assumes that, in the last phase, he will convert the RAW files to JPEGs for proofing.

The following is a revised workflow that Neil prepared for use in this book and it reflects the latest developments in new software and RAW-file thinking. If you already have Photoshop CS2, then you don't need anything more than Bridge and Adobe Camera RAW for your workflow. There is much to be said for working entirely within Bridge and Camera RAW. However, Neil tends to mix and match various other programs in his workflow. He shoots with both Canon and Nikon cameras, and his workflow is slightly different for each because he likes using Canon's proprietary software, DPP. It is an easy and fast program to use. Nikon's software is more limited for a volume workflow, and for volume work the other RAW editor programs are far more efficient. Neil uses BreezeBrowser Pro for his initial workflow and for the actual editing process. He also works with Capture One Pro, which is an impressively fast tool for editing images in RAW.

This workflow will certainly change over time as software specific to RAW workflows is developed. At the time of this writing, things are heating up with the release of Aperture, and intended release of Adobe's Lightroom.

Workflow Stages. The following is a brief overview of the basic stages in this workflow. The workflow is a methodical system and allows you to make sure you always have back-ups so that you can retrace your steps at any point, in case you make mistakes or there are problems.

1. Image transfer; copying images from CF cards to hard drive.
2. Verifying RAW files and renaming (let Bridge or Capture One generate previews).
3. Creating back-ups to DVD and/or other hard drives.
4. Editing RAW files (select, sort, add metadata, and correct RAW files).
5. Production; process to JPEG for proofing/web galleries.

Neil notes that the most important step for a good digital workflow is to make sure you have the best possible exposure and white balance when taking the actual photograph. The closer the image is to ideal, the less work you have to do in post-production. Keeping your exposures and white balance consistent for entire sequences of images will also greatly speed up your workflow. This way, if there are any slight errors, you can adjust groups of images instead of laboring over individual shots. This will drastically cut down on the time you need to spend on them in post-processing.

1. Image Transfer and Downloading Images. Since Neil uses a PC, he employs Windows Explorer for this stage, making sure to download all the folders that the camera created. It is important to copy the files, not move them, when you download. With Nikon files, Neil has also used Nikon Transfer, which works very well. With Canon's multiple folder system, he recommends checking out Downloader Pro, which handles that specific very well.

2. Verifying Images and Renaming Files. Many of the image browsers show the embedded JPEGs, not the actual images generated from the RAW files. It is therefore possible to have corrupt RAW files without realizing it. Therefore, you should not reformat your CF cards until you are sure your RAW files are not corrupt.

If he needs to reuse his CF cards the next day, Neil knows he can't rely on programs such as DPP, Nikon Browser, or BreezeBrowser to tell him that his images have not been corrupted. In that case, he uses either Capture One or Adobe Camera Raw to generate previews before he proceeds. It takes some time for Capture One and ACR to generate thumbnails, but they are more accurate and allow you to verify your RAW files.

After verifying the images, he orders the images chronologically by the time each image was created. With your cameras synchronized for the same time, it is easy to combine images from multiple cameras into a single folder and have them appear chronologically.

He then batch-renames the images using Breeze-Browser Pro. Although numerous programs allow batch renaming, Neil likes BreezeBrowser because it allows him to simultaneously rename RAW files and JPEGs in the same folder. Neil notes that many photographers rename their files later in their workflow. "I like to rename my files immediately to a more recognizable name than that generated by the camera," he says.

3. Creating Back-ups to DVD and/or Other Hard Discs. Before editing the images, Neil makes a DVD

Neil van Niekerk captures all of his originals in RAW (NEF) format because it gives him the flexibility and control over each image that he demands. Credit: Neil van Niekerk for Milton Gil Photography.

When Neil van Niekerk opens the image in Photo Capture One, which he now uses frequently, he instantly knows what he will want to do to the final image—in this case, some diffusion via Gaussian Blur and some burning in to diminish the background tonality. Original made with Canon EOS 1DS and 70–200mm f/2.8L lens. Credit: Neil van Niekerk for Milton Gil Photography.

copy of the verified images and also copies the files to two other hard discs. "You can't be too paranoid about back-ups," he says. "Hard discs *will* fail, so it is important to be thorough and consistent here."

At this point, Neil formats his CF cards for the next shoot. Yet, he still double checks to make sure that he downloaded all the folders, and that he recognizes images from each card in the folder that he uses for editing. He also checks that the images on the computer don't appear to be missing any sequences.

There's no going back once you start shooting and write files onto a formatted card, so you have to be absolutely sure. It even makes sense to have enough cards to do an entire weekend's wedding shoots, so that you don't have to re-use any cards until the following weekend.

4. Editing RAW Files (Selecting, Sorting, Adding Metadata, and Correcting RAW Files). During editing,

Neil recommends starting with general settings, then working down to the specific ones. In other words, do global changes to white balance and exposure first, and then touch up single images as needed. Since Neil is editing for proofing and web galleries at this point, it helps his speed and efficiency to aim for "good," not "perfect."

Neil also suggests applying keywords and metadata at this point if you want to search for specific photos later on. This depends on how or whether you want to keep track of your images. This step can also be earlier on in the workflow, depending on the software you work with. Keywords are recorded in various ways, which will also be affected by the software you work with.

Neil finds it is easier to "edit in" than to "edit out," so he selects the photos he wants to keep (i.e., those that go to proofing and for the galleries). To do this, he

creates two folders: "RAW selected" and "RAW discarded." He then sorts his images accordingly by adding check marks to the files he wants to keep. "I might delete images that just don't make it," he says, "but generally I put the non-keepers in the 'discarded' folder, in case I need to go back."

At his point, rotate images, if needed. This can be done with any of the programs, so Neil uses whichever program he is editing the RAW files in—DPP, Capture One, or Adobe Camera Raw. Nikon Browser is also good for this.

He then edits the RAW files for white balance and exposure. For efficiency, it is essential to adjust groups of images together. "It is usually better to start with the white balance first," says Neil, "since adjusting the white balance can often affect the exposure if you look at the various channels. If an image appears very warm and shows overexposure in the red channel, then correcting the white balance could very well eliminate the exposure warnings in your editing program."

Neil starts with a rough white balance using white-balance tool (eye-dropper), then fine-tunes his results with the sliders. "There are tools like the WhiBal Card that will help white balance correction in post-production," he notes, "but mostly I click on white shirt collars and such to bring my images close to the correct white balance." You can also adjust contrast and brightness as part of exposure correction.

Sharpening is left as part of the conversion to JPEG, since resizing might be involved in generating proofs or images for web galleries. Either way it is better to have less sharpening in the initial workflow.

Noise reduction can also be applied at this point. The setting you use will depend on your camera make and model and the chosen ISO.

You can also convert some images to black & white or sepia at this point. DPP is especially great for this. It offers various filters that will help brighten the skin tones—akin to how you would've used an orange or red filter with black & white film to brighten skin tones.

"I might also crop some of the RAW files to improve composition," Neil says. Capture One and Adobe Camera Raw both have brilliantly fast ways of applying crops to multiple images. So if you routinely crop large numbers of images to 4x5 or 8x10, then a RAW workflow will save you considerable effort. Copying the crop to multiple RAW files is faster than doing the same for the JPEGs in Photoshop. You can also custom crop in ACR for web-sized images.

5. *Converting RAW Files to JPEGs.* "At this point," says Neil, "I should have all my images corrected for white balance and exposure and even some of them cropped. I will now make another back-up of the RAW files—but this time of the corrected and edited RAW files." To do this, he uses a batch process. If you're using Adobe Camera Raw, you could use actions to convert to JPEG, but saving directly from ACR is much faster—and it works in the background. Batch processing the RAW files to JPEGs can take a while, depending on how many images you are processing and your computer's processing speed. "I normally perform this function overnight," Neil says.

With the batch process complete, Neil burns another DVD of these JPEGs and also keeps copies of the converted JPEGs on one of the external hard drives. "I don't bother converting to TIF," he says, "because all the potentially destructive correction and editing work was done on the RAW files already. So quality is still very high, and there is still the option of going back to a specific RAW file should there be a quality problem."

At this point, the initial RAW workflow is complete, and the JPEGs can be sent off to the lab for proofs or web galleries can be created. Excluding the time the software took to generate the previews, Neil is usually able to finish editing a wedding within three hours. Even though all that sounds like a lot of effort, with some practice it becomes a fast and completely reliable way of working with digital images. "And in shooting RAW," says Neil, "You have the option to change most of the settings again."

See www.planetneil.com for more information.

7.
THE WEDDING DAY: PREPARATION AND KEY MOMENTS

*T*he wedding photographer's best weapon, so to speak, is preparedness. Knowing each phase of the wedding day, when and where it will happen, and the details of each mini-event during the day will help build mutual confidence and rapport and raise the percentage of successful shots taken.

The wedding photojournalist works hard on wedding day. Here Chuck Maring tracks the bride and groom as they all cross a busy intersection. Maring has his eye to the viewfinder, camera firing and a smile on his face as if he's having as much fun as his couple. Photograph by Jennifer Maring.

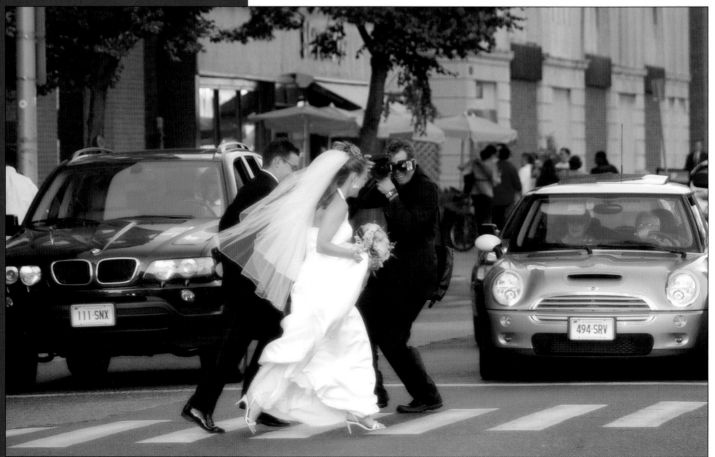

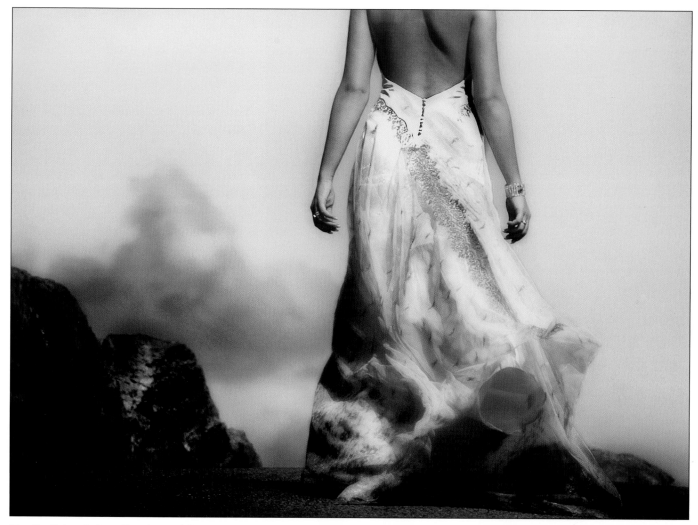

Martin Schembri studies the wedding gown in detail so that he can make a stunning image of the dress for the album.

MEETING WITH THE BRIDE AND GROOM

Arrange a meeting with the couple at least one month before the wedding. Use this time to take notes, formulate detailed plans, and get to know the couple in a relaxed setting. This initial meeting also gives the bride and groom a chance to ask any questions of you they may have. It is also the time when the couple can tell you about any special pictures they want you to make, as well as let you know of any important guests that will be coming from out of town. Make notes of all the names—the parents, the bridesmaids, the groomsmen, the best man and maid of honor—so that you can address each person by name.

It will be time well spent and allows you a month after the meeting to check out the locations, introduce yourself to the people at the various venues (including the minister, priest, or rabbi), and get back to the couple if there are any problems or difficulties. Note the color scheme the couple will be using, and get detailed information from the florist, the caterer or banquet manager, the limo driver, the band, and so on. You may find out interesting details that will affect your timetable or how you make certain shots. Australian photographer Martin Schembri also uses this time to see and study the gown in a fashion and design sense; he uses these mental notes as preparation for the album design.

When you meet with the clergyman, make sure you ask about any special customs or traditions that will be part of the ceremony. At many religious ceremonies you can move about and even use flash, but it should really be avoided, in favor of a more discreet, available-light approach. Besides, available light will provide a more intimate feeling. At some churches you may only be able to take photographs from the back, in others you may be offered the chance to go into a gallery, choir loft, or balcony. Also, be prepared not to be allowed to make

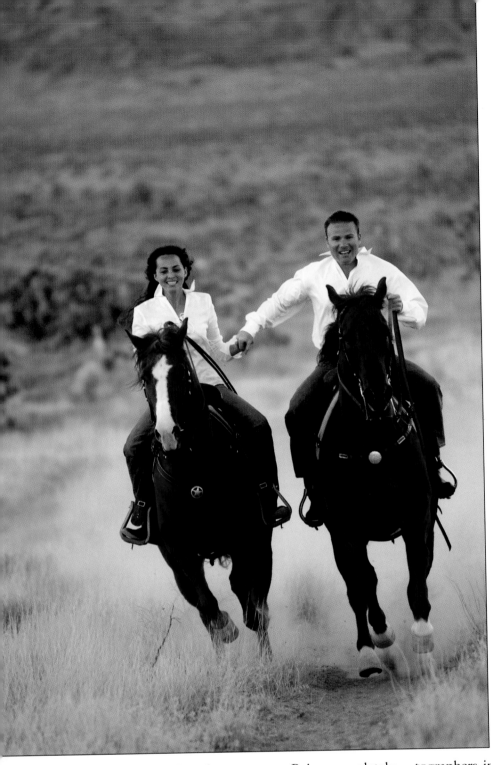

Joe Photo made this impressive engagement portrait of the bride and groom on horseback with a Nikon D1X and Nikkor 80–200mm f/2.8 lens at $1/500$ second at f/2.8.

time as or a little before the groom, who should arrive about a half-hour before the ceremony. At that time you can make portraits of the groom and his groomsmen. Bridesmaids will arrive at about the same time. Additionally, you need to determine approximately how long the ceremony will last.

ENGAGEMENT PORTRAIT

The engagement portrait can be a significant part of forging a good relationship with the bride and groom. After a couple books a wedding, wedding photographers Alisha and Brook Todd call the couple once a month to check in. When the contract goes out, they send a bottle of Dom Perignon with a handwritten note. They soon schedule the engagement portrait, which is a stylized romantic portrait of the couple made prior to the wedding day at the location of the couple's choice. Once the wedding day arrives, they have spent quality time with the couple and been in touch numerous times by phone and in person. "We really try to establish a relationship first," says Brook. "It's how we do business."

Since this one image is so important to establishing a good rapport between photographer and couple, many photographers include the engagement portrait as part of their basic coverage. In other words, they don't charge extra for it.

pictures *at all* during the ceremony. Being completely invisible during the ceremony is actually a positive. You may still be able to make shots with long lenses from a discreet position, but to interrupt the ceremony will take attention away from the most significant moment of the day.

You should know how long it takes to drive from the bride's home to the ceremony. Inform the bride that you will arrive at least an hour to 45 minutes before they leave. You should arrive at church at about the same

Many couples use the engagement portrait for newspaper announcements. Often, the photographer will also produce a set of note cards using the engagement portrait as a cover. The couple can then use these as thank-you notes after they return from the honeymoon. These can be delivered to the bride's mother before the wedding or while the couple is away.

PRE-CEREMONY COVERAGE

Usually, the actual wedding photography begins at the bride's home as she is getting ready. Some of the most endearing and genuine photographs of the day can be made at this time. Be wary, however, as emotions are high. If chaos reigns in the bedrooms, don't be afraid to step back and get out of the way. By being a good observer and staying out of the way, you are sure to get some great shots, because no one has time to worry about you; it's like you're invisible.

It is important to avoid photographic clichés and, instead, be alert for the unexpected moments. There are all too many photos of the bride looking into the mirror as she gets ready. One of the unique fascinations brides have is with their shoes and with the act of putting them on. You might also create shots featuring the maid of honor or the bride's mother, both of whom are integral to the bride's preparations. Since the ceilings of most homes are quite low and upstairs bedrooms often have multiple windows, you can usually expose these images by bounce flash and/or available light.

It is important not to wear out your welcome at the bride's home. Although you should arrive an hour or more earlier (before the bride is due to arrive at the ceremony), you should be prepared to leave and arrive at the ceremony at the time the groom arrives. Photographing him before the ceremony will also produce some wonderful shots, and it is also a great time to create a formal portrait of the groom and his groomsmen. It is also a good time to produce some casual portraits. Although he won't admit it, the groom's emotions are running high and it usually leads to some good-natured bantering between the groom and his friends.

If you have an assistant or are shooting the wedding as a team, have your counterpart be prepared to handle the groom at the ceremony, while you stay with the bride at her home. You may want to get a shot of her getting into the limo—an exercise in physics. Her dad saying goodbye is always a good shot, as well.

This is also a good time to capture many of the details of the wedding attire. The flowers being delivered at the bride's home, for instance, can make an

Marcus Bell does exceptional portraits of the groom. Here he photographed the groom and his best man before the ceremony in an edgy, editorial style. You can sense the anticipation on the groom's face.

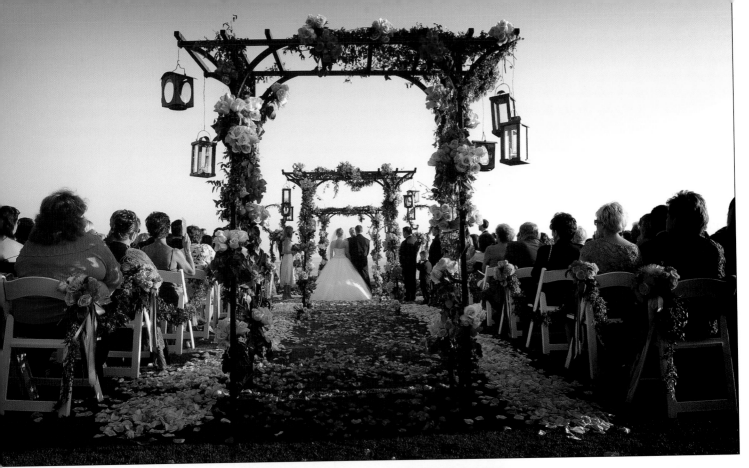

ABOVE—This Southern California wedding is anything but typical. Joe Photo captured all the nuances in one shot made from behind—the warmth of the day, the beauty of the rose petals strewn everywhere, and the solemnity of the ceremony. Careful focusing with the 17mm lens helped Joe carry focus from the foreground to infinity. The shot was made with a Nikon D1X and 17mm AF Nikkor lens. LEFT—Having two shooters for the ceremony is almost a necessity. Jeffrey and Julia Woods are a husband-and-wife team who really cover the day's events as a team. Here the just-wed couple exhibits a moment of pure joy as they walk up the aisle to exit the church.

interesting still life, as can many other accessories for the wedding-day attire.

PHOTOGRAPHING THE CEREMONY

Before the guests arrive is a good time to create an overall view of the church, as no two weddings ever call for the same exact decorations. If there is an overhead vantagepoint, like a choir loft, this is a good place to set up a tripod and make a long exposure with good depth of field so that everything in the image is sharp. This kind of record shot will be important to the historic aspects of the wedding album. This is also a great place to shoot

from as the bride enters the church with the pews all filled with people.

When the bride arrives at the ceremony and is helped out of the car, sometimes by her dad, there are ample opportunities for good pictures. It isn't necessary to choreograph the event—there will already be plenty of emotion between the bride and her father. Just be ready and you will be rewarded with some priceless images.

When the bridesmaids, flower girls, ring bearers, mother of the bride, and the bride herself (sometimes with her dad) come up the aisle, you should be positioned at the entrance of the church so that the subjects are walking toward you. If you are part of a team, have another photographer positioned at another location so that you can get multiple viewpoints of this processional.

Once the ceremony begins, be as discreet and invisible as possible, shooting from an inconspicuous or even hidden vantagepoint and working by available light. Often a tripod will be necessary as exposures, even with a fast ISO setting, may be on the long side, like $\frac{1}{15}$ second. Weddings are solemn occasions and the ceremony itself will present many emotion-filled moments. Keep

in mind that the ceremony is more important than the photographer or even the pictures, so prioritize the event by being as discreet as possible. Be alert for surprises and pay special attention to the children who will do the most amazing things when immersed in a formalized ritual like a wedding.

For the ceremony, try to position yourself so that you can see the faces of the bride and groom, particularly the bride's face. This will usually place you behind the ceremony or off to the side. This is when fast film and fast, long lenses are needed, since you will almost surely be beyond the range of the frequently used

TOP—Waiting for the ceremony to begin, one should be aware of anxious moments that precede the big event. Photograph by Jeffrey and Julia Woods. RIGHT—Stick with the bride and groom—you never know what will happen. Once the ceremony is concluded and they are in each other's company, there is sometimes a spontaneous outburst of emotion and glee. Mark Cafeiro captured this joyous moment with a Canon EOS 1-D Mark II and wide-angle zoom lens at the 40mm setting.

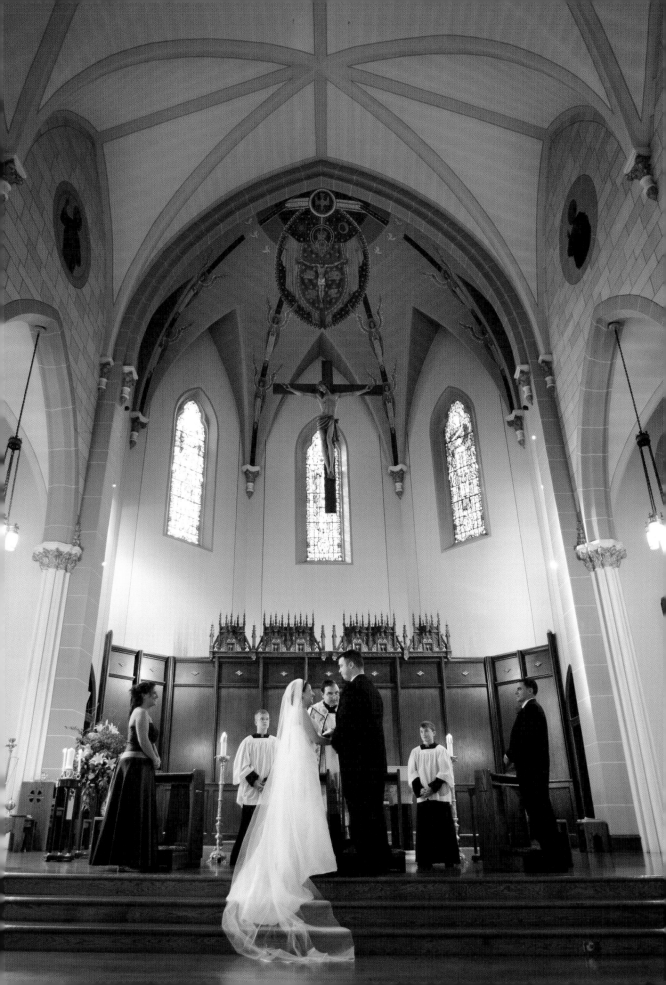

80–200mm zoom. Look for the tenderness between the couple and the approving expressions of the best man and maid of honor. Too many times the photographer positions him- or herself in the congregation. The minister or rabbi will not be purchasing any photographs, so it is the faces of the bride and groom that you will want to see.

If you are behind the ceremony, you cannot immediately bolt to the back of the church or synagogue to capture the bride and groom walking up the aisle as man and wife. This is when it is important to have a second shooter, who can be perfectly positioned to capture the bride and groom and all of the joy on their faces as they exit for the first time as man and wife.

Be aware of changing light levels. Inside the church, it will be at least three to four stops darker than in the vestibule. As the couple emerges, the light will change drastically and quickly. Know your exposures beforehand and anticipate the change in light levels. Many a gorgeous shot has been ruined by the photographer not changing exposure settings to compensate for the increased light levels.

When photographing the bride and groom leaving the church, include the door frame as a reference. If photographing from the side, try to position yourself on the bride's side, so she is nearest the camera. Because of diminishing perspective, if the groom is in the foreground, the bride will look even smaller than she might be in reality.

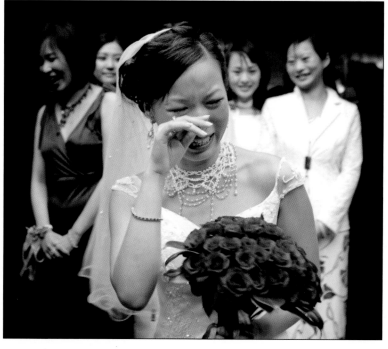

Sometimes the bride and groom being driven to the reception can be one of the most stylish and memorable photos made through-out the wedding day. Photograph by Cal Landau.

If there is to be a rice, confetti, or bubble toss, these are best photographed with a wide-angle lens from close up, so that you can see not only the bride and groom but the confetti (or rice, or bubbles), and the faces of the people in the crowd. It's a good idea to choreo-graph this shot with the crowd so they throw their con-fetti on your signal, usually as the couple reaches the steps. Be sure to tell them to throw the stuff above the head height of the bride and groom so that it descends into your photograph. While choreographed, the shot will look unstaged as the bride and groom will be unaware of your planning and will undoubtedly flinch when they see the rice/confetti in the air. This type of scene is best photographed with two photographers.

Many photographers who love photographing wed-dings have told me that they get overwhelmed some-times by the emotion of the wedding event. The best way to keep your emotions in check is to focus your attention on every detail of the event. Immersing your-self in the flow of the wedding and its details will help you to be more objective and put you in touch with the many subtleties of the day.

PHOTOGRAPHING THE RECEPTION

Since the bride and groom are so preoccupied at the reception, they actually get to see very little of it and therefore depend on your pictures to provide memories. You will want to photograph as many of the details and events of the reception as possible.

Be sure to make several good overviews of the deco-rated room. This should be done just before the guests enter, when the candles on the tables are lit and every-

thing looks perfect. Be sure to photograph the details—table bouquets, place settings, name cards, etc.. These things help enrich the finished wedding album

The photo opportunities at the reception are endless. As the reception goes on and guests relax, the opportunities for great pictures will increase. Be aware of the bride and groom all the time, as they are the central players. Fast lenses and a higher-than-normal ISO settings will help you to work unobserved.

Be prepared for the scheduled events at the reception—the bouquet toss, removing the garter, the toasts, the first dance, and so on. If you have done sufficient preparation you will know where and when each of these events will take place and you'll be prepared to light and photograph each one. Often, the reception is best lit with a number of corner-mounted umbrellas, triggered by your on-camera flash. That way, anything within the perimeter of your lights can be photographed

If the reception is home to some interesting architectural elements such as this spiral staircase and skylight, be sure to make a portrait of the bride and groom in those environs. The really good locations can be discovered by visiting the venues before the big day. Photo by David Worthington.

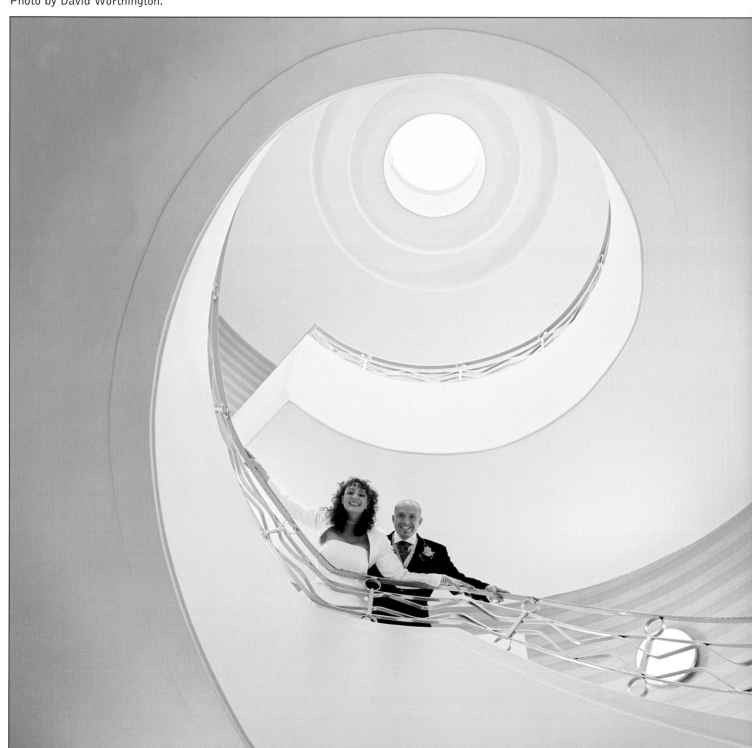

ABOVE—Joe Photo makes it part of his coverage to do a still life of the couple's rings on top of the wedding invitation. FACING PAGE—High points at the reception might include some exceptional dancing. Mike Colón captured this terrific dancer with a Nikon D1X and short zoom lens at $^1/_{200}$ second at f/2.8 by available light. Note that the exposure was made at the perfect peak of action, where the subject is momentarily motionless.

by strobe. Be certain you meter various areas within your lighting perimeter so that you know what your exposure will be everywhere within the reception area.

The reception calls upon all of your skills and instincts—and things happen quickly. Don't get caught with an important event coming up and only two frames left in the camera. Use two camera bodies and always have plenty of exposures available, even if it means changing CF cards before you're ready to. People are having a great time, so be cautious about intruding upon events. Observe the flow of the reception and carefully choose your vantage point for each shot. Be sure to coordinate your efforts with the wedding planner or banquet manager. He or she can run interference

for you as well as cue you when certain events are about to occur, often not letting the event begin until you are ready.

Photojournalists know how to get the shot without alerting the people being photographed. Some photographers walk around the reception with their camera held low, but with both hands in position on the camera so that they can instantly raise the camera to eye level, frame the image, and shoot. Others use a wide-angle lens set to wide-area autofocus in one of the camera's autoexposure modes. With the camera at waist or hip height, the photographer will then wander around the reception, mingling with the guests. When a shot seems to be taking place, they will aim the camera up toward the people's faces and fire, never even looking through the viewfinder.

The final shot of the day will be the couple leaving the reception, which is usually a memorable photo. Like so many events at the reception, planned or spontaneous, it is best to have as many angles of the event as possible, which is why so many wedding photographers work with a shooting partner or assistants.

Lighting. *Pole Lighting.* Many photographers employ an assistant at the reception to walk around with a barebulb flash attached to a monopod. The strobe is slaved and can be triggered by a radio transmitter on the camera or by an on-camera flash. The pole light can be positioned anywhere near the subjects and can be set to overpower the on-camera flash by one f-stop so that it becomes a main light.

Your assistant should be well versed in the types of lighting you like to create with this rig. For instance, if he or she is at a 45-degree angle to the subject and the light is held about four feet over the subjects' head height, the resulting lighting will resemble Rembrandt-style side lighting. If you prefer to backlight your subjects, then your assistant can position himself behind the group to create a rim-lighting effect.

When taking an exposure, read the room light first and set the flash output to the same aperture as the existing light exposure. That way the flash will not overpower the room lights.

Videographer's Lighting. If a wedding video is being produced, you will have the luxury of the videographer's rigging and lighting the reception hall with hot lights—usually quartz halogen lights, which are very

This is one of the finest "first dance" shots this writer has ever seen. The scene is lit with a powerful flash outside the ballroom and by candlelight on the tables. You will also notice that another photographer's flash is going off simultaneously. Photograph by Cal Landau.

bright and will make your reception photography much easier. The only problem is that you will have to adjust your white balance to compensate for the change in color temperature of the quartz lights.

Handheld Video Lights. Many of the Australian wedding photographers, like David Williams and Yervant, use handheld battery-powered video lights as accent or fill lights. Williams uses a low-wattage light, around 15––20 watts, for just a little light to add mood or color or accent to a scene. Yervant uses a 100-watt Lowel Light that will overpower room light depending on the distance at which it is used.

The effects are quite beautiful and, because you can change your white balance on the fly, the color balance will be superb and match the room lighting. Sometimes the photographers will hold the light themselves, sometimes they'll give it to an assistant if a certain lighting effect is desired.

One of the great things about these lights is that you can see the effect you will get in the viewfinder. Also, since the light units are small and maneuverable, you can feather them quite easily, using the more dynamic edge of the light.

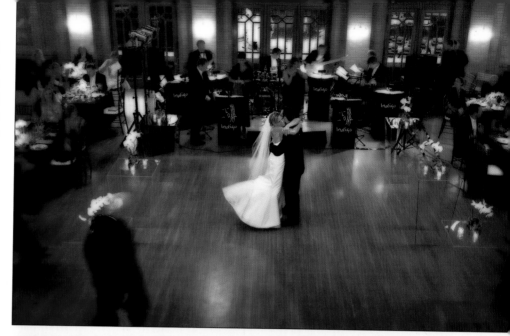

TOP RIGHT—This photo of the couple's first dance is amazing. Joe Photo made it at $^1/_8$ second at f/2.8 and then enhanced the image in Photoshop with filters and Gaussian Blur. BOTTOM RIGHT—The bride's bouquet toss is often filled with trickery and deceit on the part of the bride. Here Mark Cafiero captured this lovely bride in the middle of a belly laugh, apparently at her maidens' expense.

RINGS

The bride and groom usually love their new rings and will want a close-up shot that includes them. This is a great detail image in the album. You can use any attractive pose, but remember that hands are difficult to pose. If you want a really close-up image of the rings, you will need a macro lens and you will probably have to light the scene with flash or video light, unless you make the shot outdoors, in strong window light, or using strong available room light.

THE CAKE-CUTTING

One of the key shots at the reception is the cutting of the wedding cake. This is often a good opportunity to make an overhead group shot of the crowd surrounding the bride and groom. Bring along a stepladder for these types of shots. A second shooter is a good idea in these situations so that details and priceless moments won't be missed. Also, be sure to get a still life of the cake before it is cut. Both the couple and the baker/caterer will want to see a beautiful shot of their creation.

THE FIRST DANCE

The first dance is an important moment in the reception and one that you will want to document thoroughly. Don't turn it into a cliché.

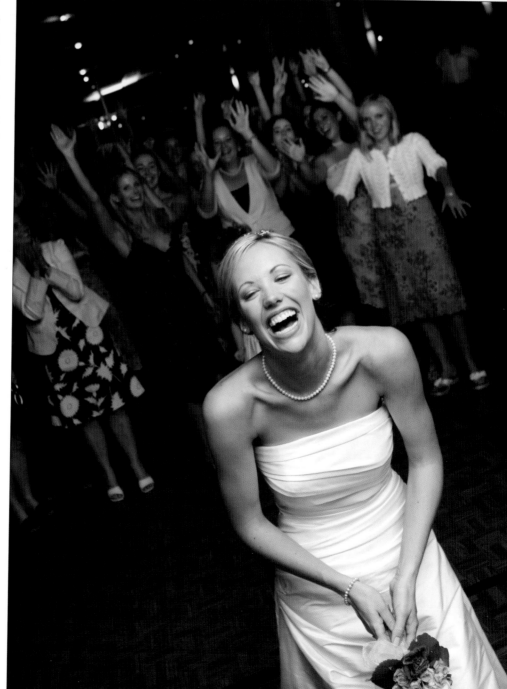

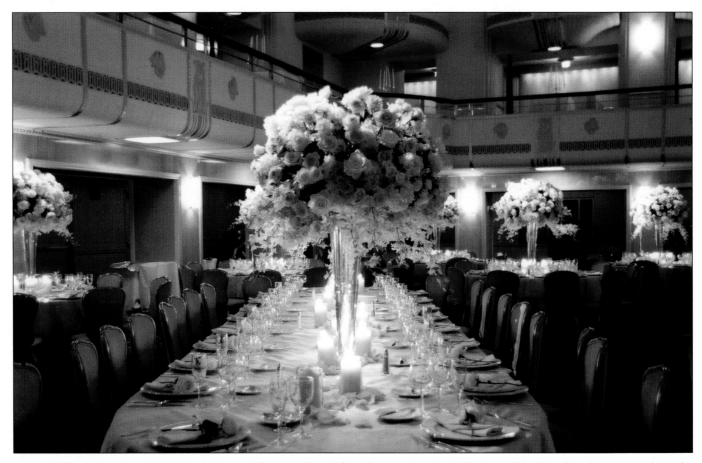

ABOVE—It is always a great idea to photograph the reception before the guests arrive. Photograph by Ron Capobianco, made at the Waldorf Hotel in New York City. FACING PAGE, TOP—The little ones involved in the ceremony are always a treat to photograph and always present good photo opportunities. Photograph by Marcus Bell. FACING PAGE, BOTTOM—If you are fortunate enough that the bride and groom are staying at the location of the reception, you can arrange to get some great shots after all the guests have left and the couple relaxes and winds down. Photograph by Cal Landau.

Just observe, and try to shoot it with multiple shooters so as not to miss the good expressions. You will be rewarded with emotion-filled, joyful moments.

THE BOUQUET TOSS

This is one of the more memorable shots at any wedding reception. Whether you're a photojournalist or traditionalist, this shot always looks best when it's spontaneous. You need plenty of depth of field, which almost dictates a wide-angle lens. You'll want to show not only the bride but also the expectant faces in the background, which usually necessitates two shooters. Although you can use available light, the shot is usually best done with two flashes—one on the bride and one on the ladies hoping to catch for the bouquet. Your timing has to be excellent as the bride will often "fake out" the group (and you), just for laughs. Try to get the bouquet as it leaves the bride's hands.

TABLE SHOTS

Table shots are the bane of every wedding photographer's day. They rarely turn out well, are often never ordered, and are tedious to make. If your couple absolutely wants table shots, ask them to accompany you from table to table. They can greet their guests and it will make the posing quick and painless. You might also consider talking the couple into one big group shot that encompasses nearly everyone at the reception. These are always fun to participate in and to photograph.

LITTLE ONES

One of the best opportunities for great pictures comes from spending some time with the smallest attendees and attendants: the flower girls and ring bearers. They are thrilled with the pageantry of the wedding day and their involvement often offers a multitude of picture opportunities.

8.
GROUPS AND FORMALS

\mathcal{E}ven in a photojournalistic wedding, up to 15 percent of the coverage may be groups and formals. This is simply because gatherings of this type bring together many people from the couple's lives that may never be assembled together again. That makes it

In this beautiful portrait by Cherie Steinberg Coté, the line of the shoulders and the tilt of both heads is different, providing dynamic lines. Also, note that the faces are not turned directly toward the camera. Also note that the bodies are turned in toward one another for a more intimate pose. Cherie made this portrait with a Nikon D70, backlit sunlight, and a large reflector for fill.

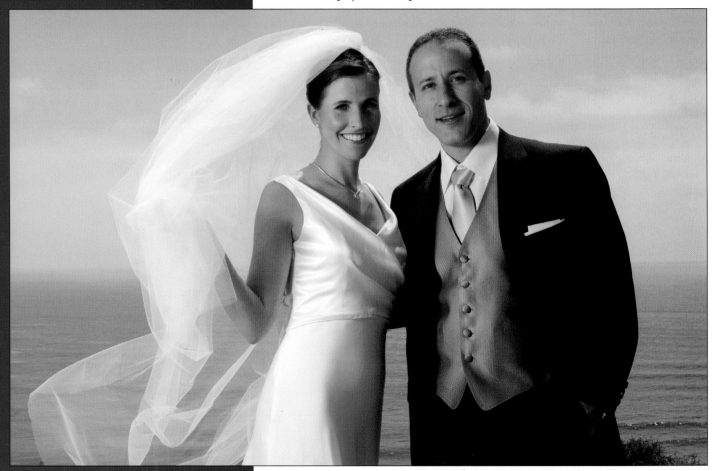

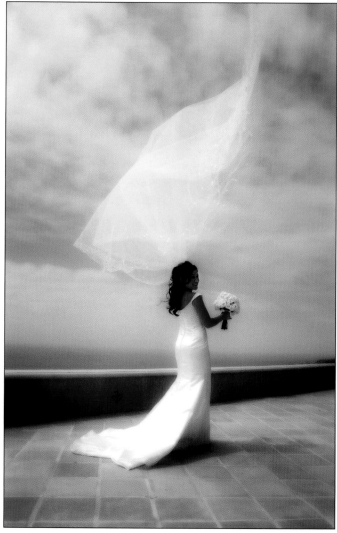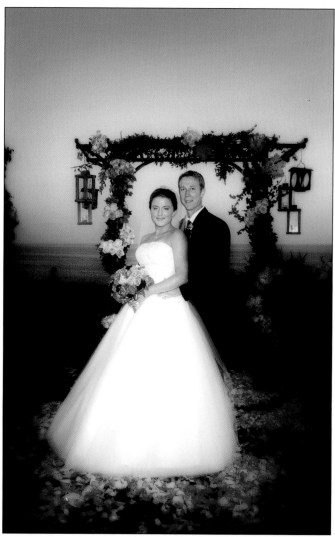

LEFT—Joe photo started out photographing the bridal formal with this amazing setting on the Pacific coast. Then the breeze helped him out, creating this beautiful graphic flourish. Photo made with Nikon D1X and 17mm lens. RIGHT—Wide-angle portraits, such as this image by Joe Photo, require the subjects to be in the center of the frame to avoid distortion. Note that the bride has her weight on her back foot with her front foot forward to extend the line of the dress. In this pose, the bride and groom are facing the same way but their heads are tilted in toward each other. Joe used flash set to the same output as the twilight exposure. He worked the image extensively in Photoshop to produce the soft, dreamy effect of the roses and trellis.

imperative that pictures be made to commemorate the occasion. Also, brides and families want to have a formal remembrance of the day, which may include the formal portraits of bride alone, groom alone, bride and groom together, bride and bridesmaids, groom and grooms-men, full wedding party, family of the bride, family of the groom, and so on. These images are something that the couple expects the photographer to make on the day of their wedding.

As you will see, however, formals and groups done by a contemporary wedding photojournalist differ greatly from the stiff "boy–girl, boy–girl" posing of the traditional wedding photographer, where everyone is looking directly into the camera lens. A lot of imagination goes into the making of these formals and many times, one cannot really tell that the photographer staged the moment. The photographer preserves the naturalness and spontaneity in keeping with the photo-journalistic spirit.

Wedding photojournalists draw a great deal from editorial and advertising photography. In fact, many of the more famous wedding photojournalists also do work for bridal magazines, illustrating new bridal fashions and trends. The fact that these pictures are posed and highly controlled doesn't seem to diminish their popularity among brides. The images have a certain

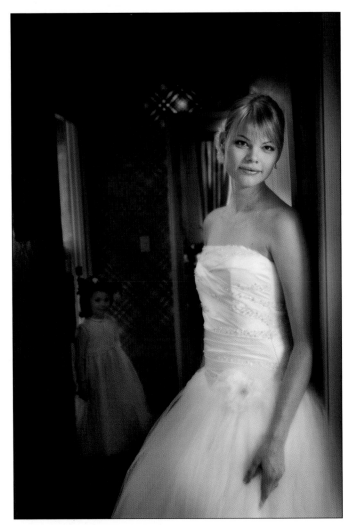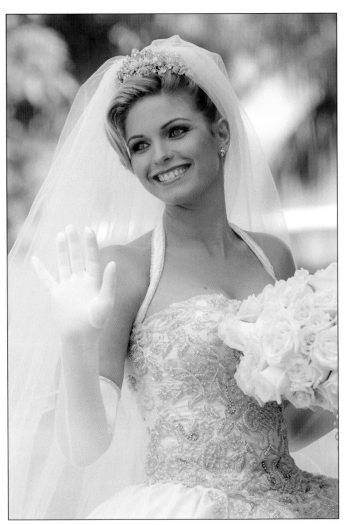

LEFT—In this delightful three-quarter length portrait by Marcus Bell, the photographer positioned the bride's face so that it is in the seven-eighths view—almost straight on, but with slightly more of the right side of her face showing. She is positioned off to the side of the frame so the figure of the flower girl in the background would balance the composition. RIGHT—In this animated portrait, photographer Charles Maring had the bride look away toward some guests so that her face was in a classic three-quarters view, with her head tilted toward the near shoulder in a traditional feminine pose. FACING PAGE—Maurucio Donelli positioned his bride in profile, then stretched the veil forward in the frame to provide a subtle window to the bride. The lighting is slightly behind her to create a shadow side facing the camera and to highlight the frontal planes of her face and the gown. The careful lighting brings out the delicate beadwork in the wedding dress.

style and elegance, regardless of whether or not the subjects are looking into the camera.

The rigors of formal posing will not be seen in these photos. But knowledge of posing fundamentals will increase the likelihood of capturing people looking their best. No matter what style of photography is being used, there are certain posing essentials that need to be at work. The more you know about the rules of posing and composition, and particularly the subtleties, the more you can apply to your wedding images. And the more you practice these principles, the more they will become second nature and a part of your technique.

POSING

The Head-and-Shoulders Axis. One of the basics of good posing is that the subject's shoulders should be turned at an angle to the camera. With the shoulders facing the camera, the person looks wider than he or she really is. Simultaneously, the head should be turned a different direction than the shoulders. This provides an opposing or complementary line within the photograph, that when seen together with the line of the body, creates a sense of tension and balance. With men, the head is often turned the same general direction as the shoulders (but not exactly the same angle); with

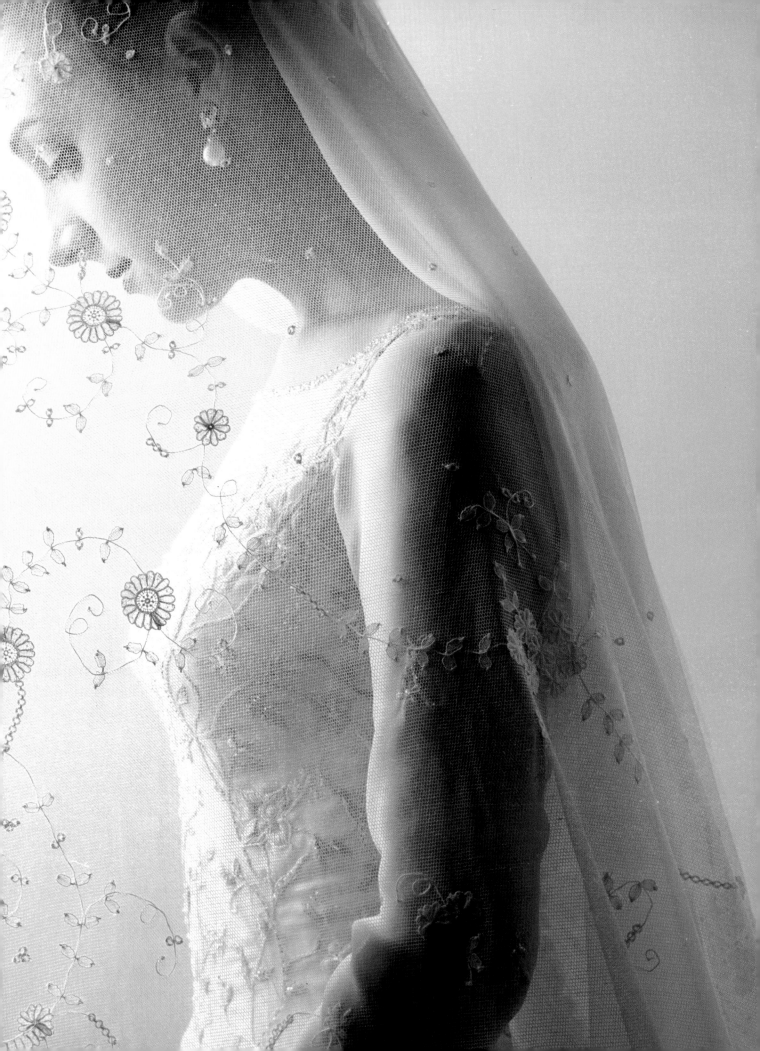

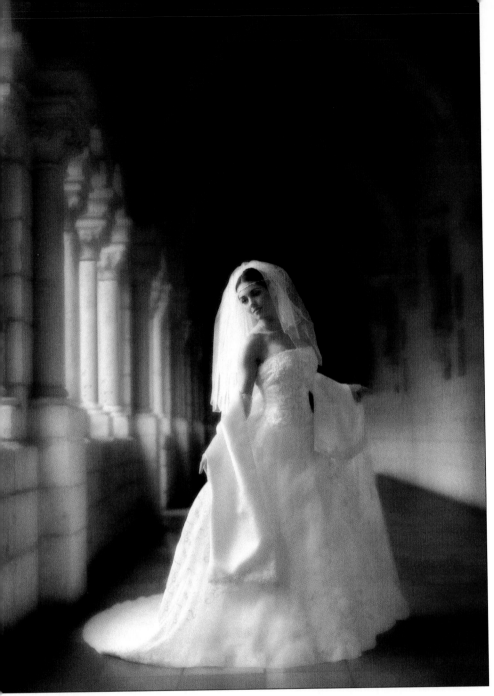

In this elegant full-length portrait, Tom Muñoz captured just a bit of the hands, but they serve to extend the diagonal line in the portrait. Tom had the bride raise her arms slightly to show the wrap that is part of her gown. Notice the arch in her neck and back that provides a beautiful graceful curve. Muñoz also had her tilt her head toward the near shoulder. Her gaze follows the forward arm to extend all the logical lines within the portrait. It's a study in posing perfection.

women, the head is usually turned toward the near shoulder for the classic "feminine" pose.

Arms should not be allowed to fall to their sides, but should project outward to provide gently sloping lines and a "triangle base" to the composition. This is achieved by asking the subjects to move their arms away from their torsos. Remind them that there should be a slight space between their upper arms and their torsos. This triangular base in the composition directs the viewer's eye upward, toward the face.

Weight on the Back Foot. The basic rule of thumb is that no one should be standing at attention with both feet together. Instead, the shoulders should be at a slight angle to the camera and the front foot should be brought forward slightly. The subject's weight should generally be on the back leg/foot. This creates a bend in the front knee and causes the rear shoulder to drop slightly lower than the forward one. When used in full-length bridal portraits, a bent forward knee will give an elegant shape to the dress. With one statement, "Weight on your back foot," you have introduced a series of dynamic lines into an otherwise static pose.

Head Angles. The face should be viewed from at least slightly to the side. This is a much more attractive view than a straight-on pose. There are three basic head positions, relative to the camera, found in portraiture. Knowing the different head positions will help you provide variety and flow to your images. In group images, you may end up using all three head positions in a single pose (the more people in the group, the more likely that becomes). Note that, with all of these head poses, the shoulders should still be at an angle to the camera.

The Seven-Eighths View. This is when the subject is looking slightly away from camera. If you consider the full face as a head-on "mug shot," then the seven-eighths view is when the subject's face is turned just slightly away from camera. In other words, you will see a little more of one side of the subject's face. You will still see the subject's far ear in a seven-eighths view.

The Three-Quarters View. This is when the far ear is hidden from camera and more of one side of the face is

visible. With this pose, the far eye will appear smaller because it is farther away from the camera than the near eye. This makes it important, when posing subjects in a three-quarters view, to position them so that the smallest eye (people usually have one eye that is slightly smaller than the other) is closest to the camera. This way both eyes appear to be the same size.

Of course, you will not usually have the luxury of time to refine your group poses to this degree. When photographing the bride and groom, however, care should be taken to notice these subtleties.

Profile. In the profile the head is turned almost 90 degrees to the camera. Only one eye is visible. When photographing profiles, adjust your camera position so that the far eye and eyelashes disappear.

The Gaze. The direction the person is looking is important. If the subject is aware of your presence, start by having the person look at you. If you step away slightly and engage your subject in conversation, allowing you to hold the subject's gaze, you will create a slight rotation to the direction of the face. You can also have the person look away from you until you best utilize the light and flatter your subject. One of the best ways to enliven the subject's eyes is to tell an amusing story. If they enjoy it, their eyes will smile—one of the most endearing expressions that people can make.

One of the best photographers I've ever seen at "enlivening" total strangers is Ken Sklute. In almost every one of his images, the people are happy and relaxed in a natural, typical way. Nothing ever looks posed in his photography—it's almost as if he happened by this beautiful picture and snapped the shutter. One of the ways he gets people "under his spell" is by his enthusiasm for the excitement of the day. It's contagious and his affability translates into attentive, happy subjects.

Hands. Hands can be strong indicators of character, just as the mouth and eyes are. Posing hands properly can be very difficult because in most portraits they are closer to the camera than the subject's head, and thus appear larger. One thing that will give hands a more natural perspective is to use a longer lens than normal (75–130mm in the 35mm digital format). Although holding the focus of both hands and face is more difficult with a longer lens, the size relationship between them will appear more natural. And if the hands are

slightly out of focus, it is not as crucial as when the eyes or face of the portrait are soft.

One should never photograph a subject's hands pointing straight into the camera lens. This distorts the size and shape of the hands. Always have the hands at an angle to the lens, and if possible, try to "bow" the wrist to produce a gentle sloping line. Try to photograph the outer edge of the hand when possible. This gives a natural, flowing line to the hand and wrist and eliminates distortion.

As generalizations go, it is important that women's hands have grace, and men's hands have strength.

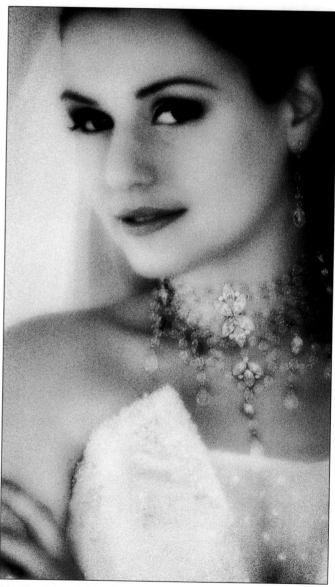

Martin Schembri had his beautiful bride face away from the camera but directed her to bring her gaze back to him at the camera position for a more engaging pose. Notice how he handled the visible single hand, photographing its edge with the fingers separated and gracefully bent.

Subtle posing techniques abound in this blue-toned portrait by David Worthington. The antique car's running light not only provides a good posing prop, but it allows the bride to separate from the car, revealing her slim waistline and the details of her embroidered dress.

CAMERA HEIGHT

When photographing people with average features, there are a few general rules that govern camera height in relation to the subject. These rules will produce normal, undistorted perspective.

For head-and-shoulders portraits, the rule of thumb is that camera height should be the same height as the tip of the subject's nose. For three-quarter-length portraits, the camera should be at a height midway between the subject's waist and neck. In full-length portraits, the camera should be the same height as the subject's waist.

In each case, the camera is at a height that divides the subject into two equal halves in the viewfinder. This is so that the features above and below the lens–subject axis will be the same distance from the lens, and thus recede equally for "normal" perspective.

When the camera is raised or lowered, the perspective (the size relationship between parts of the photo) changes. When you raise your camera height, the portion of the subject below the lens axis becomes farther

away, and thus appears smaller. Conversely, if you lower the camera height, the portion of the subject above the lens axis becomes smaller because it is farther away from the film plane. This is particularly exaggerated with wide-angle lenses.

There are many reasons to raise or lower the camera height, most of which have to do with corrective portraiture—making a more flattering likeness by diminishing the effect of certain body parts. For instance with a middle-aged man who is overweight and balding, you might raise the camera angle and have him look up at the camera. While it won't cure his baldness, it will trim a few pounds from around his middle. Another example might be a bride with a wide forehead. In this case, lower the camera angle so that that area of her head is diminished in size because it is farther from the camera.

While there is little time for many such corrections on wedding day, knowing a few of these rules and introducing them into the way you photograph people will make many of these techniques second nature.

PORTRAIT LENGTHS

Three-Quarter- and Full-Length Poses. When you photograph a person in a three-quarter- or full-length pose, you have arms, legs, feet, and the total image of the body to deal with. A three-quarter-length portrait is one that shows the subject from the head down to a region below the waist.

Note that when you break the composition at a joint—an elbow, knee or ankle, for example—it produces a disquieting feeling. As a result, it is best to compose your three-quarter-length images with the bottom of the picture falling mid-thigh or mid-calf.

A full-length portrait shows the subject from head to toe. The person can be standing or sitting, but it is important to angle the person to the lens—usually at a 30- to 45-degree angle to the camera. If they are standing, make sure your subject has their weight on their back foot. Be sure to have the feet pointing at an angle to the camera. Feet look stumpy when shot head-on.

Head-and-Shoulder Portraits. With close-up portraits of one or more people, it is important to tilt the head and retain good head-and-shoulders axis positioning. Shoulders should be at an angle to the camera lens and the angle of the person's head should be at a slightly different angle. Often head-and-shoulders portraits

are of only the face—as in a beauty shot. In these images, it is especially important to have a dynamic element, such as a diagonal line, which will create visual interest.

In a head-and-shoulder's portrait, all of your camera technique will be evident, so focus is critical (start with the eyes) and lighting must be flawless. Then, use changes in camera height to correct any irregularities.

FORMAL PORTRAITS OF THE COUPLE

Scheduling. In your game plan, devote about 10 to 15 minutes to the formal portraits of the bride and groom

TOP RIGHT—Sometimes an overhead camera height provides such an unusual perspective that it is a very natural choice for a bridal portrait. There are no corrective techniques involved, only that the photographer, Anthony Cava, wanted a little different view. BOTTOM RIGHT—Yervant used a very low camera angle to photograph this bride. The lighting is so minimal that only a sliver of her face is illuminated. One of Yervant's favorite techniques is to use a 100-watt quartz-halogen video light on location for his portraits. The light can be feathered or softened easily and quickly for elegant close-range lighting. BELOW—Mauricio Donelli created this very elegant full-length profile portrait using a single diffused strobe and no fill light for dramatic effect. He had his bride turn her head back toward the camera slightly so that just the eyelashes of the far eye are visible. The open door adds depth and intimacy to the portrait.

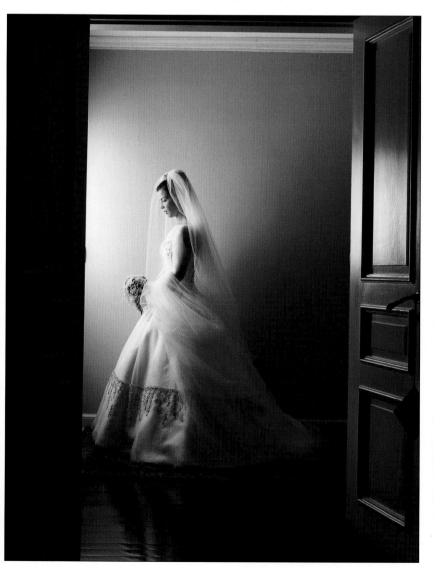

TOP—Mauricio Donelli made this enticing close-up portrait of the bride. Notice the design of the image. Follow the line of the eyebrow, down the nose through the neckline of the dress, back up through the veil and then back to the eyebrow. It's a very clever and effective means of keeping the viewer's eye within the image. BOTTOM— Yervant enjoys having the bride play with her veil. He has created a number of signature images of similar scenes. Here the bride is tossing her veil into the breeze and watching with delight. He photographed her from a low camera angle so that all of the motion and lines ascend upward, like her gaze.

alone. The bride can be done at her home before the wedding; the groom can be photographed at the ceremony before everyone arrives. You will have to wait, in most circumstances, until after the wedding ceremony (but before the reception) to photograph the bride and groom together. Often, formals are done before the bride and groom leave the church grounds.

Formal Bridal Portrait. In the bride's portrait, you must reveal the delicate detail and design elements of her bridal gown. Start with good head and shoulder axis, with one foot forward and weight on her back leg. Her head should be dipped toward the near (higher) shoulder, which places the entire body into a flattering "S-curve," a classic pose.

The bouquet should be held in the same hand as the foot that is placed forward and the other hand should come in behind the bouquet. Have her hold the bouquet slightly below waist level, revealing the waistline of the dress while creating a flattering bend to the elbows.

For another portrait, turn her around and have her gaze back at

ABOVE—Scheduling a time to photograph the groom and his groomsmen is an important element of the album. Here, Marcus Bell photographed the boys in a light-hearted moment. The image has a carefree editorial style. RIGHT—Tom Muñoz is a master at the formal bridal portrait. The location, with its open arches receding into the background and its coral and sand colors, ideally offsets the formal gown and pose. Notice how he has arranged her pose to form an elegant S-curve. Her front foot and leg are extended outward to give a better line to the dress and her hands are delicately holding the train of the dress, a pose that extends the horizontal base of the image.

you. This reveals the back of the dress, which is often quite elegant. Don't forget about the veil—shooting through the tulle material of the veil for a close-up portrait makes a fine portrait.

If the gown has a full train, you should devise a pose that shows it in its entirety, either draped around to the front or behind her. Remember, too, to have someone help her arrange and move the dress; you don't want the train dragging around in the flower beds.

If you photograph the bride outdoors by shade, or indoors in an alcove using the directional shade from outdoors, you will probably need an assistant to hold a

LEFT—Joe Photo captured this handsome editorial portrait of the groom by leaning him on a banister, which created a strong diagonal line that defines the pose. He used available window light and bounce flash for the lighting and the expression he elicited makes this shot memorable. He used controlled blurring and other Photoshop effects to enhance the portrait. RIGHT—Normally, large people are not photographed head on as it makes them look even larger. The trick was that Joe Photo allowed the black tuxedo to merge with the dark tones already in the image, thus blurring the lines of reality. The pose also makes the groom look exceedingly strong and masculine. In contrast, note the slimming effect of turning the bride to a near-profile pose. FACING PAGE, TOP—In this formal portrait, Joe Photo let the surroundings dictate how he would render the scene. The pose is stately and almost architectural, tying in to the formal elegance of the room. He white-balanced the scene for the outdoors "cloudy," allowing the tungsten interior lights to record even warmer. FACING PAGE, BOTTOM—Ron Capobianco made this formal portrait in a vineyard, an unusual but perfect place for a formal portrait of the bride and groom.

reflector close to her to bounce additional light into her face. This will give a sparkle to her eyes and also fill in any shadows caused by directional lighting.

Formal Portrait of the Groom. Generally speaking, the groom's portrait should be less formal than the bride's. Strive for a relaxed pose that shows his strength and good looks. A three-quarter-length pose is ideal for the groom because you are less concerned about showing his entire ensemble than you are about the bride's.

If the groom is standing, use the same "weight on the back foot" philosophy as before. The front foot should be pointed at an angle to the camera. With the shoulders angled away from the camera lens, have the groom tilt his head toward the far shoulder in the classic "masculine" pose.

Side lighting often works well—and the classic arms-crossed pose is usually a winner; just remember to show the edge of the hands and not let him "grab" his biceps, as this will make him look like he's cold.

Another good pose is to have the groom's hands in his pockets in a three-quarter-length pose. Have his thumbs hitched on his pants pockets so that you can

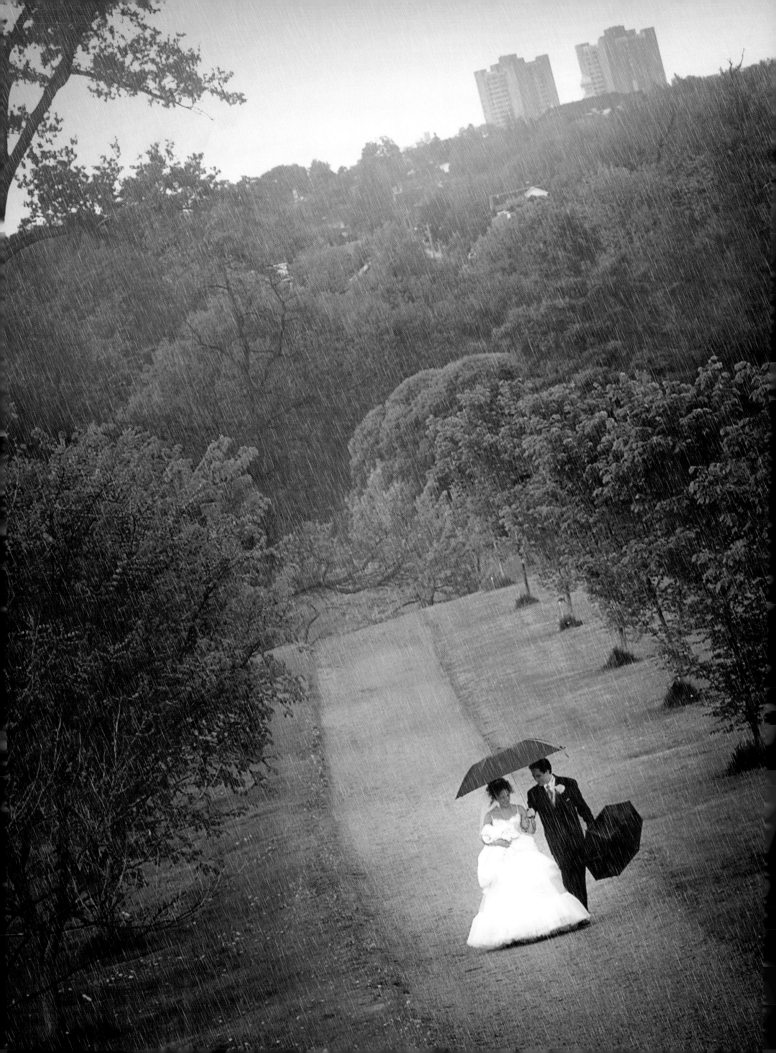

break up all of the dark tones of his tuxedo. Also, if he has cuffs and cuff links, adjust his jacket sleeves so that the cuffs and cuff links show and look good. It's always a good idea to check the groom's necktie to make sure it's properly tied.

Another good pose is to have him rest one foot on a stool, bench, or other support that is out of view of the camera. He can then lean forward toward the camera on his raised knee.

A gentle smile is better than a serious pose—or one of the "big smiley laughing" variety. Although there are no hard and fast rules here, "strong" and "pleasant" are good attributes to convey in the groom's portrait.

The men's fashion magazines are a good source of information on contemporary poses.

Formal Portrait of the Bride and Groom. The most important formal portrait is the first picture of the bride and groom immediately after the ceremony. Take at least two portraits, a full-length shot and a three-quarter-length portrait. These can be made on the grounds of the church or synagogue, in a doorway, or in some other pleasant location, directly following the ceremony.

The bride should be positioned slightly in front of the groom and they should be facing each other but each at a 45 degree angle to the camera. Weight should be on the back leg for both, and there should be a slight bend in the knee of the bride's front leg, giving a nice line to the dress. They will naturally lean into each other. The groom should place his hand in the center of

Many seasoned wedding photographers will tell you that the best groups and formals occur seconds after you've told the people, "Thanks, I've got it." Everyone relaxes and they revert to having a good time and being themselves. This is a great time to fire off a few frames. You might get the great group or formal that you didn't get in the posed session.

the bride's back and she should have her bouquet in her outside hand (the other hand can be placed behind it).

Have your assistant ready and waiting in the predetermined location and take no more than five minutes making this portrait. Your assistant should have ready the reflectors, flash, meter, or other gear you will need to make the portrait.

Vary your poses so that you get a few with them looking at each other and a few looking into the camera. This is a great time to get a shot of them kissing. Believe it or not, very few images like this get made on wedding day, because the couple is so busy attending to details and guests.

GROUP PORTRAITS

You will need to photograph the groom and his groomsmen, the bride and her bridesmaids, as well as the complete wedding party in one group. Other groups you will need to photograph depend on the wishes of the couple. They may want family formals (his and hers), extended families (this is a much bigger group, usually), or a giant group shot including all of the attendees.

FACING PAGE—This rainy-day formal by Frank Cava might be the most wonderful photo in the bride and groom's album. RIGHT—The bridal party is often very big, like this one. Joe Photo created a wonderful group portrait by arranging the group into subgroups with kneeling groomsmen in the foreground and bridesmaids on the mens' knees. The group is diverse because of the different head heights. Joe also incorporated the group into the hotel grounds and used diffused overhead light, blocked by the tops of the palm trees so that it is less overhead and more frontal in nature.

This is a group of groups on a typical album spread by Jerry Ghionis. Notice how the photographer arranged the groups so the head heights are all different, making the collection look almost like a musical score. Both pages are of the bride, her bridesmaids, and her parents captured in a cohesive unit designed for the album.

You do not have to make the portraits boy–girl, boy–girl. That is usually a pretty boring shot, even if you have a great background and all else is perfect. Instead, opt for something completely unexpected. Incorporate the environment or architecture or ask your wedding group to do something uncharacteristic. Even though this is a formal, posed shot, it does not have to represent a pause in the flow of the wedding day—it can still be fun and you can still get a wonderful group image if you exercise a little ingenuity.

Variety. While it might be tempting to find a great background and shoot all of your groups with the same background, the effect will be monotonous when seen in the album. Strive for several interesting backgrounds, even if they are only a short distance apart. It will add visual interest to the finished album.

Compositional Elements. Designing groups successfully depends on your ability to manage the implied and inferred lines and shapes within a composition.

Lines are artistic elements used to create visual motion within the image. They may be implied by the arrangement of elements in the group, or inferred by grouping various elements within the scene. Lines can also be literal, like a fallen tree used as a posing bench that runs diagonally through the composition.

Shapes are groupings of like elements into diamonds, circles, pyramids, etc.. These shapes are usually a collection of faces that form a pattern. They are used to produce pleasing forms that guide the eye through the composition.

The more you learn to recognize these elements, the more they will become an integral part of your compositions. These are the keys to making a dynamic group portrait. The goal is to move the viewer's eye playfully and rhythmically through the photograph.

Number of Subjects. *Two People.* The simplest of groups is two people. Whether the group is a bride and groom, mom and dad, or the best man and the maid of

honor, the basic building blocks call for one person slightly higher than the other. A good starting point is to position the mouth of the shorter person in line with the forehead or eyes of the taller person.

Although they can be posed in parallel position, a more interesting dynamic with two people can be achieved by having them pose at 45-degree angles to each other so their shoulders face in toward one another. With this pose you can create a number of variations by moving them closer or farther apart.

Another pose for two is to have two profiles facing each other. One should still be higher than the other, allowing you to create an implied diagonal line between the eyes, which gives the portrait better visual dynamics.

Since this type of image is fairly close up, make sure that the frontal planes of the subject's faces are kept

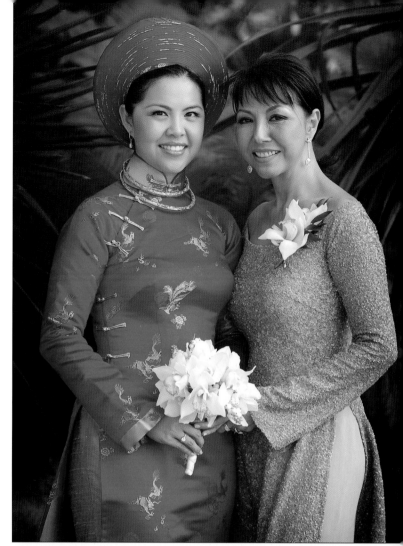

RIGHT—The smallest group is two people. The best way to handle small groups is to have the subjects facing each other at a 30- to 45-degree angle to the camera. Here, the subdued greenery in the background is perfect to offset the colorful dresses—and notice the delicate treatment of the women's' hands. Photograph by Joe Photo. BELOW—A bird's-eye view, especially made with a fisheye lens, makes an imaginative group portrait. This one, by Jeffrey and Julia Woods, is a little on the silly side, but everyone is having fun and the moment will be memorable.

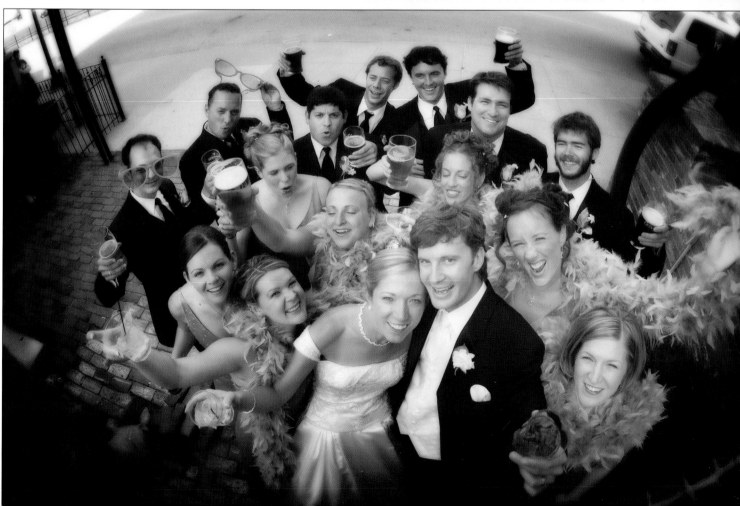

roughly parallel so that you can hold the focus on both faces.

Three People. A group portrait of three is still small and intimate. But once you add a third person, you will begin to notice the interplay of line and shape inherent in good group design. This size group lends itself particularly well to a pyramid, diamond, or inverted-triangle composition, all of which are pleasing to the eye. Note that the graphic power of a well defined diagonal line in a composition will compel the viewer to keep looking at the image.

To loop the group together, turn the shoulders of the subjects at either ends of the group in toward the center of the frame. A more subtle approach might be to just tilt the heads of those people on the end in toward the center of the group.

Also, try different vantagepoints, like a bird's-eye view. Cluster the group together, use a safe stepladder or other high vantage point, and you've got an interesting variation on the small group.

Four People. With four people, add a person to the existing poses of three described above. Be sure to keep the head height of the fourth person different from any of the others in the group. Also, be aware that you are now forming more complex shapes with your composition—pyramids, extended triangles, diamonds and arcs.

You will find that even numbers of people are harder to pose than odd. Three, five, seven, or nine people seem much easier to photograph than their even-numbered counterparts. The reason is that the eye and brain tend to accept the disorder of odd-numbered objects (asymmetry) more readily than even-numbered objects (symmetry). As you add more people to a group, remember to do everything you can to keep the film plane parallel to the plane of the group to ensure everyone in the photograph is sharply focused.

Five or Six People. With five or six people, you should begin to think in terms of separate groups tied to each other by a person who is common to both.

This is when a posing device like an armchair can come into play. An armchair is the perfect posing device for photographing from three to eight people. The chair is best positioned roughly 30 to 45 degrees to the camera. Regardless of who will occupy the seat, usually the bride, the person should be seated laterally across the cushion and posed on the edge of the chair so that all of their weight does not rest on the chair back. This promotes good sitting posture and narrows the lines of the waist and hips, for both men and women.

Using an armchair allows you to seat one person and position the others close and on the arms of the chair, leaning in toward the central person. Sometimes only one arm of the armchair is used to create a more dynamic triangle shape.

Big Groups. In big groups, the use of different levels creates a sense of visual interest and lets the viewer's eye

Although even numbers are harder to pose than odd numbers of people, David Williams did a masterful job of creating an asymmetrical grouping by arranging the groom and his best men in interlocking triangle shapes. In fact, count the number of triangles you find by "connecting the dots" of their faces. Williams is a big believer in breaking the formality of poses in order to liven things up and make them more entertaining.

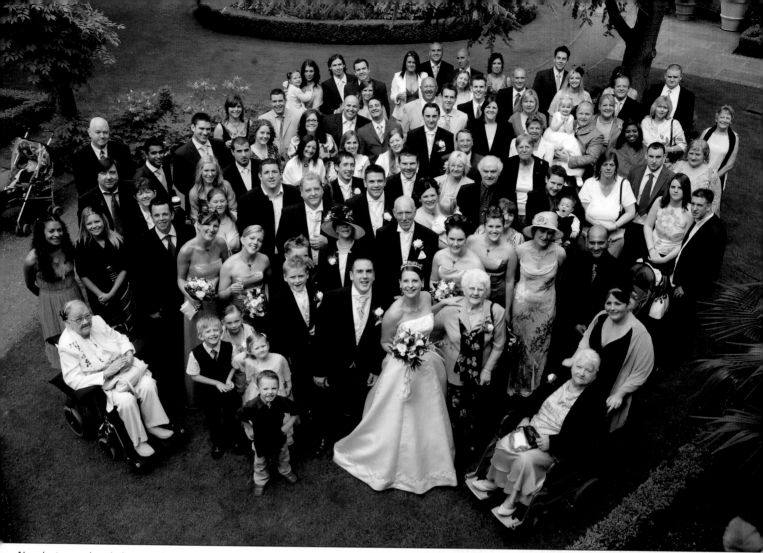

No photographer is happy about making these kinds of group portraits, but they are requested all the time. The best bet is to shoot down on the group and have an assistant at ground level to hold drink glasses and reposition those guests not paying attention. Also, the overhead point of view causes the guests to look up, filling in what might be overhead diffused lighting, which can cause deep shadows in eye sockets and under chins and noses. Photograph by Dennis Orchard.

bounce from one face to another (as long as there is a logical and pleasing flow to the arrangement). The placement of faces, not bodies, dictates how pleasing and effective a composition will be.

As your groups get bigger, keep your depth of field under control. The stepladder is an invaluable tool for larger groups because it lets you elevate the camera position so that you can keep the camera back (film plane) parallel to the group for most efficient focus. Another trick is to have the last row in a group lean in while having the first row lean back. This creates a shallower subject plane, which makes it easier to hold the focus across the entire group.

Two things you should remember about photographing large groups are (1) an assistant is invaluable in getting all of the people together and helping you to

pose them, and (2) it takes less time to photograph one large group than it does to create a series of smaller groups, so it is usually time well spent— provided that the bride wants the groups done in this way.

Panoramic Groups. If you have the capability of producing panoramic pages in your album, this is a great way to feature groups, especially large ones. Your camera technique will definitely show up with images this large, so be sure the plane of focus is aligned with your group and that everyone is in focus. Also, as needed, use the proper amount of fill-flash to fill in facial shadows across the group.

David Williams' Casual Brand of Formals. David Williams photographs groups at a wedding with both formality and informality. His compositions have good structure, with people turned in and not out of the

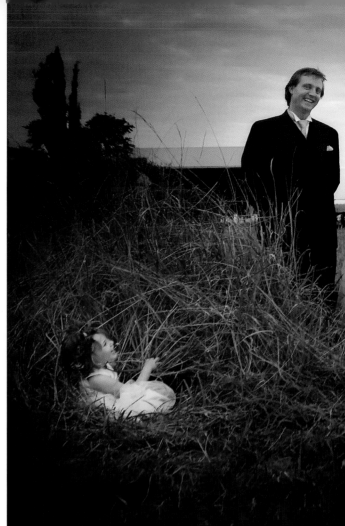

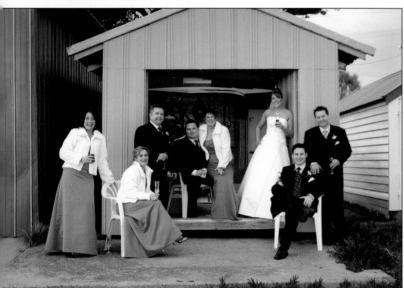

ABOVE—Two informal formal groups by David Williams. RIGHT—
Here are two delightful panoramic group portraits by Marcus
Bell. In one, he lets the background and splendid countryside
define the portrait. In the other, he lets the rolling sand dunes
create an elegant space between the couple and the bridal party.

composition. Hands, arms, legs, and feet are handled
well—but he doesn't settle for the boring symmetry of
the truly formal group. Instead, he will take one or two
people and move them outside the formal line of the
group, breaking the line and also breaking the formal
tension.

He might also make a formal group portrait in a very
informal setting, like a garage or work shed. He will not
settle for the artificial smiles so prevalent in groups. He
will talk with and work with the group until they are
loose and he can elicit natural expressions from them.
That is the charm of his formal groups; they have struc-

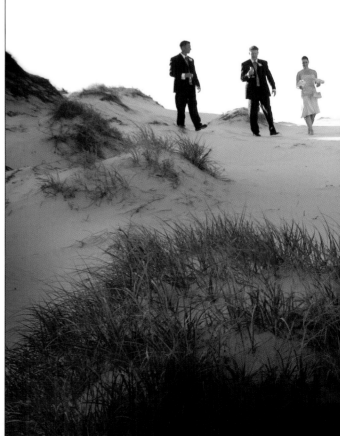

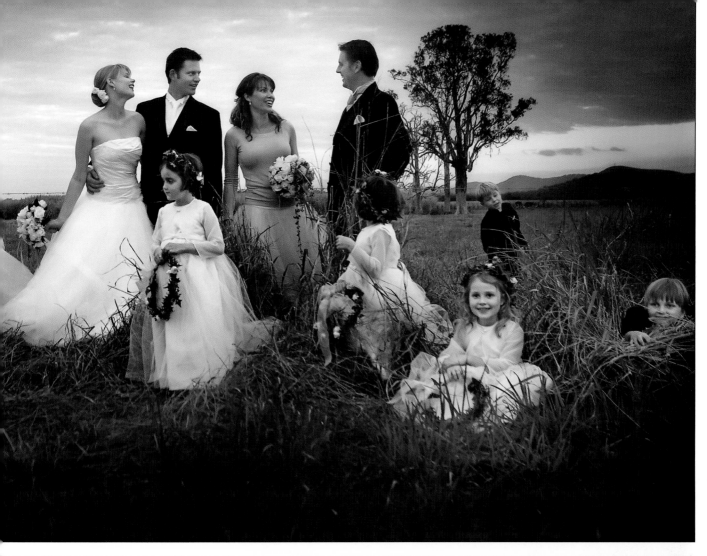

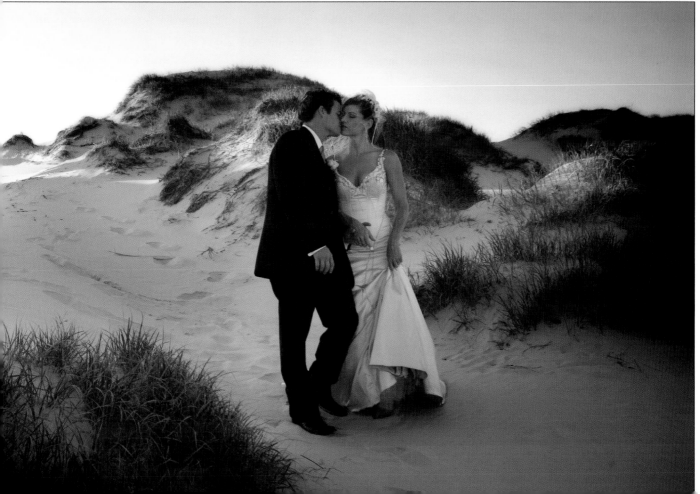

and its inherent depth of field. Focus at a distance one-third of the way into the group. This should ensure that everyone is sharp at f/5.6 or f/8 with a wide-angle lens.

Hands in Groups. Hands can be a problem in groups. Despite their small size, they attract attention—particularly against dark clothing. They can be especially troublesome in seated groups, where at first glance you might think there are more hands than there should be. A general rule of thumb is to either show all of the hand or show none of it. Don't allow a thumb or a few fingers to show. Hide as many hands as you can behind flowers, hats, or other people. Be aware of these potentially distracting elements and look for them as part of your visual inspection of the frame before you make the exposure.

In large group portraits, note that if the guests wave to the camera, this usually results in too many faces being lost behind raised arms. However, this is actually an excellent time for the bride to throw her bouquet. Ask her to throw it over her head into the crowd behind, mainly upwards and slightly to the rear.

ture and good emotional release in the same image—not so easy to do.

Technical Considerations. If you are short of space, use a wide-angle lens (or a wide-angle camera, like the Brooks Veri-Wide, a 35mm panoramic camera with a rotating shutter). Wide-angle coverage results in the people at the front appearing larger than those at the back, which may be advantageous if the wedding party is at the front of the group. Make sure everyone is sharp. This is more of a certainty with a wide-angle lens

WEDDING ALBUMS: TYPES AND DESIGNS

*L*ike any good story, a wedding album has a beginning, middle, and an end. For the most part, albums are arranged chronologically. However, there are now vast differences in presentation, primarily caused by the digital page-layout process. Often events are jumbled in favor of themes or other methods of organization. There still

Stuart Bebb is an award-winning album designer. Here you can see the effect of motion. The groom is leaning in toward the gutter of the two-page design, directing your eye toward the bride, who is facing back toward the groom It's a perfect arrangement of left and right-hand pages. Bebb used four stills with the natural yellow stone to contrast the overall blue page. Yellow and blue are opposites on the color wheel and provide maximum contrast and visual tension on the pages.

The four identical panels, as they go from deep purple to bright blue, form a visual gateway to the eye, drawing the viewer from left to right across both pages and on to the next page of the album. It's as if Bebb created a visual signage system to direct the viewer to linger here only long enough to be charmed and then move on.

must be a logic to the layout and it should be apparent to everyone who examines the album. The wedding album has changed drastically, evolving into more of a storytelling medium. Still, album design is basically the same thing as laying out a book and there are some basic design principles that should be followed.

DESIGN PRINCIPLES

Look at any well designed book or magazine and study the images on left- and right-hand pages. They are decidedly different but have one thing in common. They lead the eye into the center of the book, commonly referred to as the "gutter." These layouts use the same design elements photographers use in creating effective images: lead-in lines, curves, shapes, and patterns.

Guiding the Eye. If a line or pattern forms a "C" shape, it is an ideal left-hand page, since it draws the eye toward the gutter and across to the right-hand page. If an image is a backward "C" shape, it is an ideal right-hand page. Familiar shapes like hooks or loops, triangles or circles are used in the same manner to guide the eye into the center of the two-page spread and across to the right-hand page.

There is infinite variety in laying out images, text, and graphic elements to create this left-to-right orientation. For example, a series of photos can be stacked diagonally, forming a line that leads from the lower left-hand corner of the left page to the gutter. That pattern can be mimicked on the right-hand page, or it can be contrasted for variety. For instance, a single full "bleed" photo (extending to the edges of the page) with a more or less straight up-and-down design might be used. This produces a blocking effect, stopping the eye at the vertical within the image. The effect is visual motion; the eye follows the diagonal on the left to the vertical image on the right.

Even greater visual interest can be attained when a line or shape that is started on the left-hand page continues through the gutter, into the right hand page, and back again to the left-hand page. This is the height of visual movement in page design. Visual design should be playful and coax the eye to follow paths and signposts through the elements on the pages.

Variety. When you lay out your album images, think in terms of variety of size. Some images should be small, some big. Some should extend across the spread. Some, if you're daring, can even be hinged and extend outside (above or to the right or left) the bounds of the album. No matter how good the individual photographs are, the effect of an album in which all the images are the same size is static.

Variety can also be introduced by combining black & white and color images—even on the same pages. Try

combining detail shots and panoramas. How about a left-hand page with series of close-up portraits of the bride as she listens and reacts to best man's toast, which is shown on the right-hand page? Do not settle for the one-picture-per-page theory. It's static and boring as a design concept.

Visual Weight. Learn as much as you can about the dynamics of page design. Think in terms of visual weight, not just size. Use symmetry and asymmetry, contrast and balance. Create visual tension by combining dissimilar elements. Don't be afraid to try different things. The more experience you get in laying out the images for the album, the better you will get at presentation. Study the albums presented here and you will see great creativity and variety in how images are combined and the infinite variety of effects that may be created.

Remember a simple concept: in Western civilization we read from left to right. We start on the left page and finish on the right. Good page design starts the eye at the left and takes it to the right and it does so differently on every page.

ALBUM TYPES

Traditional Albums. Album companies offer a variety of different page configurations for placing horizontal or vertical images in tandem on a page or combining any number of small images. Individual pages are post-mounted and the album can be as thick or thin as the number of pages. Photos are inserted into high quality mattes and the albums themselves are often made of the finest leathers.

Bound Albums. A different kind of album is the bound album, in which all the images are permanently mounted to each page and the book bound profession-

TOP—Like notes on a score, the eye jumps from one face to the next and quite intentionally returns to the bride. An album that features such visual playfulness is bound to delight its owners. Stuart used a darkened image of Blenheim Palace, a frequent location for his weddings, as a stark and historical backdrop and a reminder that this is no "average" wedding. BOTTOM— From the same album, here is a study in formal symmetry. Stuart used perfect balance: left and right, light and dark, big and small. The visual interest comes from the content of the detail photos.

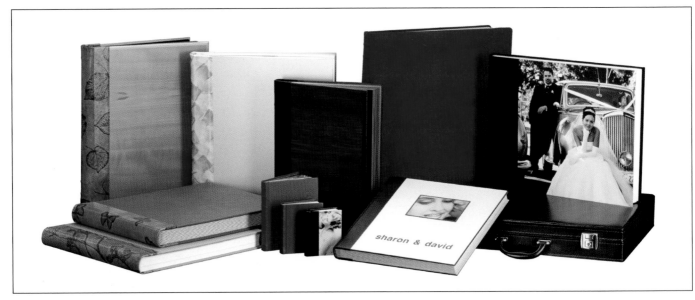

 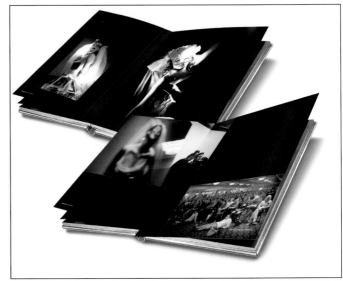

TOP—Albums Australia offers a wide range of bound digital albums with a wide variety of custom cover materials. Note the different sizes available. ABOVE LEFT—DigiCraft Albums offers a similar range of albums with superior book-type binding with fine leather covers. ABOVE RIGHT—GraphiStudio, an Italian company, offers a variety of custom-designed magazine-style albums with digital offset printing. The albums are quite spectacular.

ally by a bookbinder. These are elegant and very popular. Since the photos are dry-mounted to each page, the individual pages can support any type of layout from "double-truck" (two bleed pages) layouts to a combination of any number of smaller images.

Digital output allows the photographer or album designer to create backgrounds and inset photos, then output the pages as complete entities. With this type of album, photo sizes are not constrained by the available mats; you can size them infinitely on the computer. Once the page files are finalized, any number of pages can be output simply and inexpensively. Albums can be completely designed on the computer in Photoshop, or by using specially designed programs that are specific to the album maker.

Magazine-Style Albums. The magazine-style album features graphic page layouts with a sense of design and style. Images are not necessarily treated as individual entities but are often grouped with like images bounded by theme rather than in chronological order. This affords the photographer the luxury of using many more pictures in varying sizes throughout the album. As a result, collages and other multimedia techniques are common features of these magazine-style albums. In many cases, you also will see type used sparingly throughout the album.

Perhaps the most attractive feature of the digitally produced magazine-style albums is that they are an ideal complement to the storytelling images of the wedding photojournalist. Because there are no boundaries to page design or the number of images per page, the album can be designed to impart many different aspects of the overall story.

The difference between the standard drop-in album type and the magazine-style album is almost like the difference between an essay and a novel. The first tells the story in narrative terms only, the latter illuminates the story with subtleties.

SOFTWARE FOR ALBUM DESIGN

Martin Schembri's Design Templates. Award-winning photographer Martin Schembri has created a set of automated design templates that come on four different CDs and are designed to help photographers create elegant album page layouts in Photoshop. Four different palettes are available: traditional, classic, elegant, and contemporary. The tools are cross-platform, meaning that they can be used for Macs or PCs, and are customizable so that you can create any size or type of album with them. The program includes hundreds of templates that can be re-sized or edited to suit any format you wish. No Photoshop experience is required! Easy to learn and simple to use, just import your images, select a template, and drag your photos into each opening. You can also design your own template or purchase more designs directly from Schembri's web site: www.youselectit.com.

Yervant's Page Gallery. Page Gallery software incorporates beautiful, artistic designs and layout options, individually designed by Yervant, who is one of the most high-profile wedding and portrait photographers in Australia. Yervant pioneered this style of artistic album layout some years ago, creating phenomenal demand by the marketplace and setting a major milestone in the industry. All you have to do is choose an image file, then the software will crop, resize, and position the image into your choice of layout design. Page Gallery gives you fully automated options for changing a color image into black & white, introducing color tones and special effects for extra artistic results. The templates vary from very simple and classic designs to more complicated options, allowing the individual artist

Yervant's Page Gallery is a drag-and-drop program that works within Photoshop. His templates, some 475 of them, are only available to photographers and not to labs—unless they pay an exorbitant licensing fee. He devised this business model so that his pages would be unique and not "show up everywhere."

to compose a personalized album with each and every client. Visit www.yervant.com.au for more information.

TDA-2. Albums Australia's software, TDA-2 (TDA stands for total design ability), is a simple drag-and-drop application that produces a finished design in record time. Additionally, the program also features all of the materials variations that the company offers, such as different colors and styles of leather cover binding and interior page treatment.

THE DESIGN FACTOR

Charles Maring, a New England wedding photographer who has won numerous awards for his wedding albums, sees the digital revolution producing a whole new kind

Australian wedding and portrait photographer David Williams has created a genre of pictures that he produces at weddings called "Detail Minis," which are a series of shots loosely arranged by theme, color, or subject matter. He carries a camera with him specifically for doing the minis. It's a Finepix S2 Pro DSLR with a 50mm f/1.4 lens. He shoots with the lens wide open and uses a fast ISO speed (800) so that he can shoot in any light. He'll often use a small handheld video light for accent. The minis Williams shoots are sometimes incorporated into double-truck image panels with larger more conventionally made images. Sometimes the minis appear on a window pane–style page in groups of six or twelve. They add a flavor to the album that is unsurpassed, because invariably the minis are things that Williams saw and almost no one else even noticed.

of photographer. "I consider myself as much as a graphic artist and a designer as I do a photographer," he explains. The majority of Maring's images have what he calls "layers of techniques that add to the overall feeling of the photograph." None of these techniques would be possible, he says, without the creativity that Photoshop and other programs such as Painter give him. "Having a complete understanding of my capabilities has also raised the value of my work. The new photographer that embraces the tools of design will simply be worth more than just a camera man or woman," he says.

"The design factor has also given our studio a whole different wedding album concept that separates us from other photographers in our area. Our albums are uniquely our own and each couple has the confidence of knowing that they have received an original work of art. I am confident that this 'Design Factor' will actually separate photographers further in the years to come. I have seen a lot of digital album concepts, some good, some not so good. When you put these tools in the hands of somebody with a flare for fashion, style, and design, you wind up with an incredible album. There is something to be said for good taste, and with all of these creative tools at hand, the final work of art winds up depending on who is behind the mouse, not just who is behind the camera." Charles and Jennifer Maring own and operate Maring Photography, Inc., in Wallingford, Connecticut.

DAVID WILLIAMS' AWARD-WINNING ALBUM DESIGNS

David Williams' albums represent design purity without compromise. He uses no templates and designs each page individually. In order to get a cohesion and unity among the diverse pages, he uses gray panels and strips in the background, designed in a way that helps the viewer's eye traverse the panoramic-style pages. He has found this element (the gray areas) to be unobtrusive

FACING PAGE AND NEXT PAGE—Here are four different spreads from four different wedding albums designed by photographer David Williams. You can see the common design elements used in each one. His use of light gray background panels gives each album a brand. David also loves to use transparent images as secondary design elements. His sense of flow from page to page is impeccable.

Charles Maring is considered not only an expert wedding photographer but an expert album designer. You can see his design sense in this "double truck" in which the antique car seems to swoop across the pages.

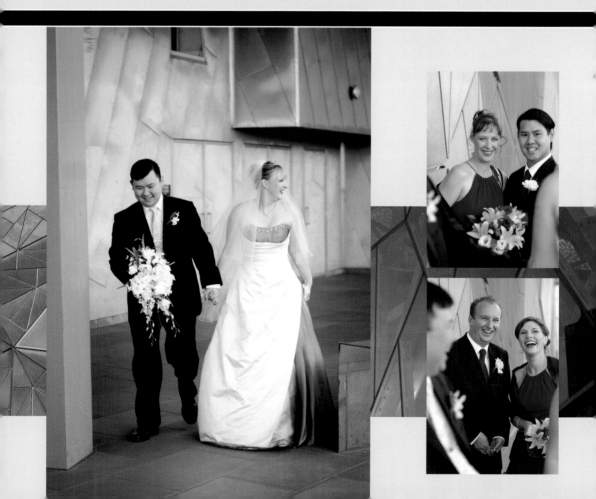

but functional. While calling very little attention to themselves, they provide a fluid visual function.

He often uses semi-transparent vellum-like overlays on his album pages. These contain images that relate to the formation of the page beneath or the tools involved. It is a very clever way of giving the album narrative detail.

Williams uses mattes (black and white) with one-inch borders. His prints slide into these matt pages and the pages get mounted in the album by Williams. They are cost-effective and elegant. He likes the mattes because they protect the prints and provide a formality and uniformity throughout the album.

ALBUM FEATURES

Covers. Albums Australia offers everything from stainless steel covers to something natural, like pearwood with a golden spine of leather imprinted with autumn leaves. Or perhaps the cover should be something artis-tic like "fusion," a brushed metal cover that can be accentuated with a spine that resembles modern art. Or how about clear cedar with a leather spine emblazoned with monarch butterflies. Or maybe something hot, like Chili Red Leather. And what could be more classically modern than the black & white photo cover with an elegant black leather spine?

Title Page. An album should always include a title page, giving the details of the wedding day. It will become a family album and it is an easy matter of using a fine-quality paper and inkjet printer to create a beautiful title page. Many inkjet printers use archival pigment inks, thus making the digital album heirloom quality. The title page will add an historic element to the album's pricelessness.

Double-Trucks and Panoramic Pages. Regardless of which album type you use, the panoramic format can add great visual interest—particularly if using the bleed-mount digital or library-type albums. Panoramics

FACING PAGE—David Williams also uses the concept of modulation, matching small and large images together on the same spread to create balance or tension within the layout. He does all his layouts from scratch, using no templates, and works strictly in Photoshop as his design program. ABOVE—Yervant's albums capture joy, love, and romance on every page.

shouldn't be created as an afterthought, though, since the degree of enlargement can be extreme. Good camera technique is essential.

Gatefolds. One of the more interesting aspects of digital albums is the gatefold, which is created using a panoramic print on the right- or left-hand side. This is

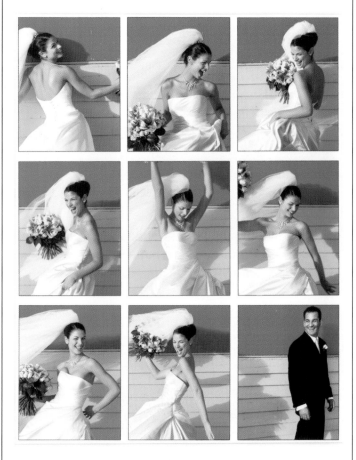

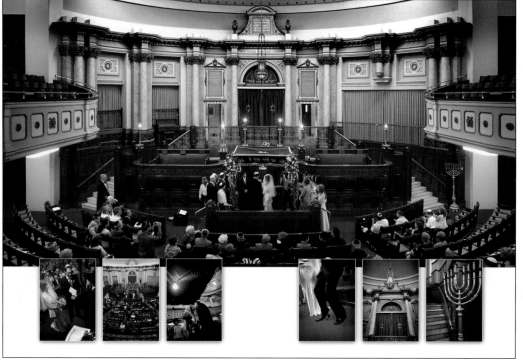

THIS PAGE—Yervant is an amazing album designer. You can see his impeccable design sense in how he treats routine pages such as the church or synagogue interior and small groups. Alternately, he will employ precise symmetry and then wild asymmetry from page to page. Cinematic techniques, like foreshadowing, make his albums a cut above the rest. FACING PAGE—Jerry Ghionis is another master album designer. His albums often incorporate stylistic techniques like paneled portraits that have an up-and-down rhythm to the page.

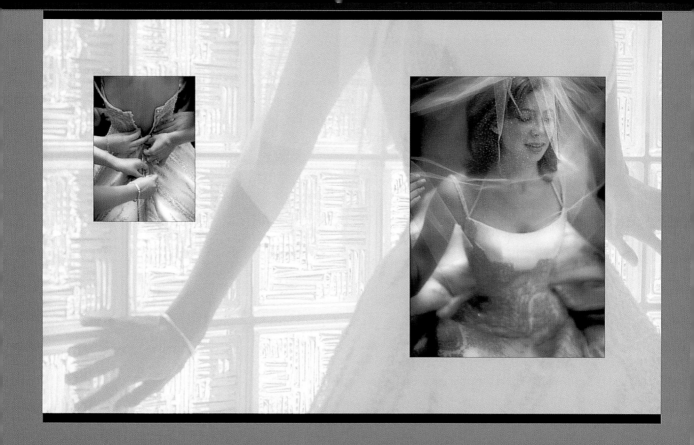

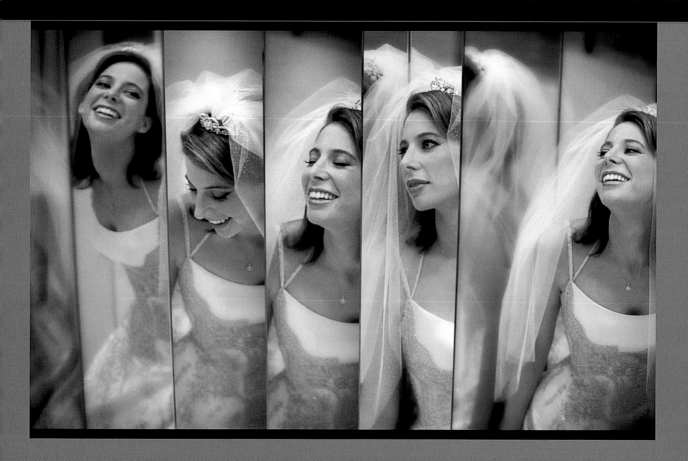

hinged so that it folds flat into the album. Sometimes the gatefold can be double-sided, revealing four page-size panels of images. The bindery can handle such pages quite easily but it provides a very impressive presentation—particularly if it is positioned in the center of the album.

Border Treatments. Whether they are created by the lab or by the photographer in Photoshop, border treatments can enliven a special section of the album.

One edge that is quite popular is called "sloppy borders," which calls for the lab to print the negatives with milled, oversize negative carriers so that the negative or frame edges show.

For digital imaging, a wide range of edge treatments is available as a series of plug-ins. Extensis frame effects operate in page-layout programs like Photoshop, which also has a full range of border treatments that are accessed by going to the Actions menu and activating Frames.atn.

Collages. Collages are image assemblies using any number of images organized either by theme or design

elements. They are best used when there is a logic and architecture to the image collage, as opposed to randomly combining images of varied sizes—although with wedding albums, a collage of reception or ceremony shots works quite well.

MINI ALBUMS

All of the album companies now offer a miniature version of the main album, small enough for brides to pop in their handbags to show all of their friends at work or at lunch. Being so portable, the mini albums get far more exposure than a large, precious album. It also works as a great promotion for the photographer.

Jerry Ghionis often ventures into the experimental, choosing a very small subject and lots of space and color that delight the eye.

Michael J. Ayers, MPA, PPA-Certified,M.Photog., Cr., CPP, PFA, APPO, ALPE, Hon.ALPE. A world leader in album design, Michael J. Ayers runs a studio in Lima, Ohio, with wedding clients all over North America. He has received the Honorary Lifetime Achievement Accolade from WPPI (Wedding and Portrait Photographers International) and the International Leadership Award at the United Nations. His work can be viewed at www.TheAyers.com.

Stuart Bebb. Stuart Bebb is a Craftsman of the Guild of Photographers UK and has been awarded Wedding Photographer of the Year in both 2000 and 2002. In 2001 Stuart won *Cosmopolitan Bride* Wedding Photographer of the Year, in conjunction with the Master Photographers Association, he was also a finalist in the Fuji wedding photographer of the Year. Stuart has been capturing stunning wedding images for over 20 years and works with his wife Jan, who creates and designs all the albums.

David Beckstead. David Beckstead has lived in a small town in Arizona for 22 years. With help from the Internet, forums, digital cameras, seminars, WPPI, Pictage and his artistic background, his passion has grown into a national and international wedding photography business. He refers to his style of wedding photography as "artistic photojournalism."

Marcus Bell. Marcus Bell's creative vision, fluid natural style and sensitivity have made him one of Australia's most revered photographers. It's this talent combined with his natural ability to make people feel at ease in front of the lens that attracts so many of his clients. Marcus' work has been published in numerous magazines in Australia and overseas including *Black White, Capture, Portfolio Bride,* and countless other bridal magazines.

Clay Blackmore. Clay Blackmore is an award-winning photographer from Rockville, MD. He has been honored by the PPA and WPPI and is a featured presenter on the lecture circuit around the United States. He started out as Monte Zucker's assistant. Clay is a member of the prestigious CameraCraftsmen of America, and is a Canon Explorer of Light.

Joe Buissink. Joe Buissink is an internationally recognized wedding photographer from Beverly Hills, California. Almost every potential bride who picks up a bridal magazine will have seen Joe Buissink's photography. He has photographed numerous celebrity weddings, including Christina Aguilera's 2005 wedding, and is a multiple Grand Award winner in WPPI print competition.

Becky Burgin, APM. Becky Burgin is the mother of Alisha Todd Burgin and Erika Burgin—and all three are award-winning wedding photographers. As a child, Becky loved fantasy stories. As an adult, she believes in wedding photography as romance and

creates a "happily ever after" theme in her photographs. She holds an Accolade of Photographic Mastery from WPPI.

Drake Busath, Master Photographer, Craftsman. Drake Busath, owner of Busath Photographers, has 25 years experience and is a second-generation professional photographer. He has spoken all over the world and has been featured in a wide variety of professional magazines. Drake has had Italy-on-the-brain since 1977 when he lived and worked for two years in Northern Italy. He now returns two or three times every year to visit and get his "fix" of Italian images, cuisine, and attitude adjustment.

Mark Cafiero. Mark graduated from the University of Northern Colorado with a degree in Business Administration with special emphasis in Marketing. He is the owner of several photography businesses, including Pro Photo Alliance, an online proofing solution for labs and professional photographers, and his own private wedding, event, and portrait business.

Ron Capobianco. Ron Capobianco's images have appeared in *Vogue, Glamour, Harpers Bazaar, The New York Times, Modern Bride,* and *Wedding Bells.* He has collaborated on several book projects including *Eclectic Living: At Home with Bari Lyn* (Harper Collins, 1998) and *Hair: The Inter-Beauty Collection* (Intercommunication Magazine, 1979) by Elena Domo.

Anthony Cava, BA, MPA, APPO. Anthony Cava owns and operates Photolux Studio with his brother, Frank. He joined WPPI and the Professional Photographers of Canada ten years ago, and at thirty-three years old became the youngest Master of Photographic Arts (MPA) in Canada. He won WPPI's Grand Award with the first print that he ever entered in competition.

Frank Cava. The co-owner of Photolux Studio in Ottawa, Frank is a successful and award-winning wedding and portrait photographer. With his brother Anthony, he has presented workshops for professional photographers in the U.S. and Canada. Frank is a member of the Professional Photographers of Canada and WPPI.

Mike Colón. Mike Colón is a celebrated wedding photojournalist from the San Diego area. Colón's natural and fun approach frees his subjects to be themselves, revealing their true personality and emotion. His images combine inner beauty, joy, life, and love frozen in time forever. He has spoken before national audiences on the art of wedding photography.

Cherie Steinberg Coté. Cherie Steinberg Coté began her photography career as a photojournalist at the *Toronto Sun,* where she had the distinction of being the first female freelance photographer. She currently lives in Los Angeles and has recently been published in the *L.A. Times, Los Angeles Magazine,* and *Town & Country.*

Mauricio Donelli. Mauricio Donelli is a world-famous wedding photographer from Miami, FL. His work is a combination of styles, consisting of traditional photojournalism with a twist of fashion and art. His weddings are photographed in what he calls, "real time." His photographs have been published in *Vogue, Town & Country,* and many national and international magazines. He has photographed weddings around the world.

Tony Florez. Tony Florez calls his unique style of wedding photography "Neo Art Photography." It is a form of fine-art wedding photojournalism that has brought him great success. He owns and operates a studio in Laguna Niguel, California. He is also an award winner in WPPI print competition.

Jerry Ghionis. Jerry Ghionis of XSiGHT Photography and Video is one of Australia's leading photographers. In 1999, he was honored with the AIPP (Australian Institute of Professional Photography) award for best new talent in Victoria. In 2002, he won the AIPP's Victorian Wedding Album of the Year; a year later, he won the Grand Award in WPPI's album competition.

Ann Hamilton. Ann Hamilton began her professional career as a journalist. Now, her wedding photography combines her journalistic sense with her artistic flair. Her images have been featured in *Wedding Bells* and *The Knot.* She also won two honorable mentions at the WPPI print competition.

Claude Jodoin. Claude Jodoin is an award-winning photographer from Detroit, Michigan. He has been involved in digital imaging since 1986 and has not used film since 1999. He is an event specialist, as well as shooting numerous weddings and portrait sessions throughout the year. You can e-mail him at claudej1@aol.com.

Jeff Kolodny. Jeff Kolodny began his career as a professional photographer in 1985 after receiving a BA in Film Production from Adelphi University in New York. Jeff recently relocated his business from Los Angeles to South Florida, where his ultimate goal is to produce digital wedding photography that is cutting edge and sets him apart from others in his field.

Kevin Kubota. Kevin Kubota formed Kubota Photo-Design in 1990 as a solution to stifled personal creativity. The studio shoots a mix of wedding, portrait, and commercial photography, and was one of the early pioneers of pure-digital wedding photography. Kubota is well know for training other photographers to make a successful transition from film to digital

Cal Landau. Cal Landau was an art major in college in the late 1960s. Although his mother was a talented painter, he did not inherit her skills, so he spent the next 30 years trying to become a professional racing driver. His father was a photographer hobbyist and gave him a Nikkormat, with which he took pictures of auto and bicycle racing for small magazines for fun. One day, someone who crewed for his race car asked him to shoot his wedding. Cal turned him down a few times and finally gave in. "Of course everyone knows the rest of the story, I fell in love with this job. So I am a very late bloomer and I pinch myself every day for how good I have it."

Charles and Jennifer Maring. Charles and Jennifer Maring own Maring Photography Inc. in Wallingford, Connecticut. His parents, also photographers, operate Rlab (resolutionlab.com), a digital lab that does all of the work for Maring Photography and other discriminating photographers. Charles Maring was the winner of WPPI's Album of the Year Award in 2001.

Bruno Mayor. Bruno Mayor is a French photographer living in Corsica. He is a member of the French trade union of photog-

raphers, the GNPP (Groupement National des Photographes Professionnels) and recently finished second overall in the French National portrait competition. You can see more of Bruno's images at his web site: www.espaceimage.com.

Mercury Megaloudis. Mercury Megaloudis is an award-winning Australian photographer and owner of Megagraphics Photography in Strathmore, Victoria, Australia. The AIPP awarded him the Master of Photography degree in 1999. He has won awards all over Australia and has begun entering and winning print competition in the U.S.

Tom Muñoz. Tom Muñoz is a fourth-generation photographer whose studio from Fort Lauderdale, FL. Tom upholds the classic family traditions of posing, lighting, and composition, yet is 100-percent digital. He believes that the traditional techniques blend perfectly with exceptional quality of digital imaging.

Laura Novak. Laura Novak is a studio owner in Delaware. She has achieved more than a dozen Accolades of Excellence from WPPI print competitions. She is also a member of PPA and the Wedding Photojournalist Association of New Jersey. Laura's work can be seen in wedding magazines across the country, including *Modern Bride* and *The Knot*.

Dennis Orchard. Dennis Orchard is an award-winning photographer from Great Britain. He is a member of the British Guild of portrait and wedding photographers, and has been a speaker and an award-winner at numerous WPPI conventions. His unique wedding photography has earned him many awards, including WPPI's Accolade of Lifetime Photographic Excellence.

Joe Photo. Joe Photo's wedding images have been featured in numerous publications such as *Grace Ormonde's Wedding Style, Elegant Bride, Wedding Dresses,* and *Modern Bride.* His weddings have also been seen on NBC's *Life Moments* and Lifetime's *Weddings of a Lifetime* and *My Best Friend's Wedding.*

Martin Schembri, M.Photog. AIPP. Martin Schembri has been winning national awards in his native Australia for 20 years. He has achieved a Double Master of Photography with the AIPP. He is an internationally recognized portrait, wedding, and commercial photographer and has conducted seminars on his unique style of creative photography all over the world.

Brian and Judith Shindle. Brian and Judith Shindle own and operate Creative Moments in Westerville, Ohio. This studio is home to three enterprises under one umbrella: a working photography studio, an art gallery, and a full-blown event-planning business. Brian's work has received numerous awards from WPPI in international competition.

Michael Schuhmann. Michael Schuhmann of Tampa Bay, Florida is an acclaimed wedding photojournalist who believes in creating weddings with the style and flair of the fashion and bridal magazines. He says, "I document weddings as a journalist and an artist, reporting what takes place, capturing the essence of the moment." He has been the subject of profiles in *Rangefinder* magazine and *Studio Photography & Design* magazine.

Kenneth Sklute. Kenneth began his career in Long Island, and now operates a thriving studio in Arizona. He has been named Long Island Wedding Photographer of The Year (fourteen times!), PPA Photographer of the Year, and APPA Wedding Photographer of the Year. He has also earned numerous Fuji Masterpiece Awards and Kodak Gallery Awards.

Alisha and Brook Todd. Alisha and Brook Todd, from Aptos, California, share their passion for art in their blend of documentary and fine-art photography. They are award-winning photographers in both PPA and WPPI competitions and have been featured in numerous wedding/photography magazines.

Neil Van Niekerk. Neil Van Niekerk is originally from Johannesburg, South Africa, but emigrated to the USA in 2000. He has a degree in Electronic Engineering and spent 16 years as an engineer at the South African Broadcast Corporation. He now works for a wedding studio in New Jersey, and is the founder of www.planetneil.com, an unusual and informative web site dedicated to digital imaging.

Marc Weisberg. Marc Weisberg specializes in wedding and event photography. A graduate of UC Irvine with a degree in fine art and photography, he also attended the School of Visual Arts in New York City before relocating to Southern California in 1991. His images have been featured in *Wines and Spirits, Riviera, Orange Coast Magazine,* and *Where Los Angeles.*

David Anthony Williams, M.Photog. FRPS. Williams operates a wedding studio in Ashburton, Victoria, Australia. In 1992, he was awarded Associateship and Fellowship of the Royal Photographic Society of Great Britain (FRPS). In 2000, he was awarded the Accolade of Outstanding Photographic Achievement from WPPI. He was also a Grand Award winner at their annual conventions in both 1997 and 2000.

Jeffrey and Julia Woods. Jeffrey and Julia Woods are award-winning wedding and portrait photographers who work as a team. They were awarded WPPI's Best Wedding Album of the Year for 2002 and 2003, two Fuji Masterpiece awards, and a Kodak Gallery Award. See more of their images at www.jw weddinglife.com.

David Worthington. David Worthington is a professional photographer who specializes in classical wedding photography. Two of David's most recent awards include being named 2003's Classical Wedding Photographer of the Year (UK, Northwest Region) and Licentiate Wedding Photographer of the Year (UK, Northwest Region).

Yervant Zanazanian, M. Photog. AIPP, F.AIPP. Yervant was born in Ethiopia (East Africa), where he worked after school at his father's photography business (his father was photographer to the Emperor Hailé Silassé of Ethiopia). Yervant owns one of the most prestigious photography studios of Australia and services clients both nationally and internationally.

Monte Zucker. Monte Zucker has earned every major honor the photographic profession can offer, including WPPI's Lifetime Achievement Award. In his endeavor to educate photographers at the highest level, Monte, along with partner Gary Bernstein, has created an information-based web site for photographers, Zuga.net.

GLOSSARY

Adobe Camera RAW. Plug-in that lets you open a camera's RAW image file directly in Photoshop without using another program to convert it a readable format.

Adobe DNG (Digital Negative). An archival format for the RAW files. Addresses the lack of an open standard for the RAW files created by individual camera models, helping ensure photographers will be able to access their files in the future.

Barebulb flash. A portable flash unit with a vertical flash tube that fires the flash illumination 360 degrees.

Balance. A state of visual symmetry among elements in a photograph or on an album page between page elements.

Bleed. A page in which the photograph extends to the edges of the page.

Bounce flash. Bouncing the light of a studio or portable flash off a surface such as a ceiling or wall to produce indirect, shadowless lighting.

Burst rate. The number of frames per second (fps) and frames per sequence that a digital camera can record. Typical burst rates range from 2.5fps for up to six consecutive shots, all the way up to 8fps for up to 40 consecutive shots.

CCD (Charge-Coupled Device). A type of image sensor that separates the spectrum of color into red, green, and blue for digital processing by the camera. A CCD captures only black & white images; the image is then passed through red, green, and blue filters in order to capture color.

Card reader. Device used to connect a memory card to a computer and download image files.

CMOS (Complementary Metal Oxide Semiconductor). A type of image sensor that consumes less energy than other chips (*see* CCD).

Color management. System of software-based checks and balances that ensures consistent color through a variety of capture, display, editing, and output devices.

Color space. An environment referring to the range of colors that a particular device is able to produce.

Color temperature. The degrees Kelvin (K°) of a light source, film sensitivity, or white-balance setting.

CompactFlash (CF) cards. A format of flash-memory card for digital cameras.

Depth of field. The distance that is sharp beyond and in front of the focus point at a given f-stop.

Double truck. Use of an single image that runs across two facing pages.

Dragging the shutter. Using a shutter speed slower than the X sync speed in order to capture the ambient light in a scene.

EXIF (Exchangeable Image Format). A standard for storing metadata. EXIF data is found under File>File Info in Photoshop.

Feathering. Misdirecting the light deliberately so that the edge of the beam of light illuminates the subject.

Fill light. Secondary light source used to fill in the shadows created by the key light.

Flashmeter. Incident light meter that measures both the ambient light of a scene and, when connected to an electronic flash, will read flash-only or a combination of flash and ambient light.

Gatefold. A double-sided foldout page in an album that is hinged or folded so that it can be opened out to reveal a single or double-page panoramic format.

Gobo. Light-blocking card that is supported on a stand or boom and positioned between the light source and subject to selectively block light from portions of the scene.

Gutter. The inside center of a book or album.

Head-and-shoulders axis. Imaginary lines running through shoulders (shoulder axis) and down the ridge of the nose (head axis). These should never be perpendicular to the lens axis.

High-key lighting. Type of lighting characterized by a low lighting ratio and a predominance of light tones.

Histogram. A graph associated with a single image file that indicates the number of pixels that exist for each brightness level. From left to right, the range of the histogram represents 0 ("absolute" black) to 255 ("absolute" white).

Incident light meter. A handheld light meter that measures the amount of light falling on its light-sensitive dome.

JPEG (Joint Photographic Experts Group). Image file format with various compression levels. The higher the compression rate, the lower the image quality.

Key light. The main light in portraiture used to establish the lighting pattern and define the facial features of the subject.

LCD (Liquid Crystal Display). On digital SLRs, a screen used to display images and data.

Lead-in line. A pleasing line in the scene that leads the viewer's eye toward the main subject; or, a line that directs the viewer's eye across a page or series of pages.

Low-key lighting. Type of lighting characterized by a high lighting ratio and a predominance of dark tones.

Metadata. Metadata (literally, data about data) preserves information about the contents, copyright status, origin, and history of documents.

Microdrive. Storage device for portable electronic devices using the CF Type II industry standard.

Monolight. A studio-type flash unit that is self-contained, including its own capacitor and discharge circuitry. Monolights

come with internal Infrared flash triggers so the light can be fired without directly connecting the flash to a camera or power pack.

Perspective. The appearance of objects in a scene as determined by their relative distance and position.

Plug-ins. Software developed by Adobe and other developers to add features to Photoshop.

Point light source. A sharp-edged light source like the sun, which produces sharp-edged shadows without diffusion.

PSD (Photoshop Document). Photoshop's default file format and the only format that supports all Photoshop features.

RAW file. A file format that records picture data as is from the sensor, without applying any in-camera corrections. In order to use RAW images, the files must first be processed by compatible software. RAW processing includes the option to adjust exposure, white balance, and the color of the image while leaving the original RAW picture data unchanged.

Reflected light meter. A meter that measures the amount of light reflected from a surface or scene. All in-camera meters are of the reflected type.

Reflector. (1) A reflective device used to bounce light onto a subject. (2) A housing on a light that reflects the light outward in a controlled beam.

Scrim. A panel used to diffuse sunlight. Scrims can be mounted in panels and set in windows, used on stands, or they can be suspended in front of a light source to diffuse the light.

Slave. A remote triggering device used to fire auxiliary flash units. These may be optical or radio-controlled.

TTL-balanced flash. Flash exposure systems that read the flash exposure through the camera lens and adjust flash output to relative to the ambient light for a balanced exposure.

Tension. A state of visual imbalance within a photograph or page layout.

Vignette. A soft-edged border around the main subject. Vignettes can be either light or dark in tone and can be included at the time of shooting or created later in printing.

Wrap-around lighting. Soft light that produces a low lighting ratio and open, well-illuminated highlight areas.

Watt-seconds. Numerical system used to rate the power output of flash units. Primarily used to rate studio strobe systems.

White Balance. The camera's ability to correct color and tint when shooting under different lighting conditions, including daylight, indoor, and fluorescent lighting.

INDEX

OTHER BOOKS FROM

Amherst Media®

MONTE ZUCKER'S
PORTRAIT PHOTOGRAPHY HANDBOOK

Acclaimed portrait photographer Monte Zucker takes you behind the scenes and shows you how to create a "Monte Portrait." Covers strategies for both studio and location shoots. $34.95 list, 8.5x11, 128p, 200 color photos, index, order no. 1846.

JEFF SMITH'S POSING TECHNIQUES FOR LOCATION PORTRAIT PHOTOGRAPHY

Use architectural and natural elements to support the pose, maximize the flow of the session, and create refined, artful poses for individual subjects and groups—indoors or out. $34.95 list, 8.5x11, 128p, 150 color photos, index, order no. 1851.

MASTER LIGHTING GUIDE
FOR WEDDING PHOTOGRAPHERS

Bill Hurter

Capture perfect lighting quickly and easily at the ceremony and reception—indoors and out. Includes tips from the pros for lighting individuals, couples, and groups. $34.95 list, 8.5x11, 128p, 200 color photos, index, order no. 1852.

PROFESSIONAL PORTRAIT POSING
TECHNIQUES AND IMAGES FROM MASTER PHOTOGRAPHERS

Michelle Perkins

Learn how master photographers pose subjects to create unforgettable images. $34.95 list, 8.5x11, 128p, 175 color images, index, order no. 2002.

PROFESSIONAL PORTRAIT LIGHTING
TECHNIQUES AND IMAGES FROM MASTER PHOTOGRAPHERS

Michelle Perkins

Get a behind-the-scenes look at the lighting techniques employed by the world's top portrait photographers. $34.95 list, 8.5x11, 128p, 200 color photos, index, order no. 2000.

MASTER'S GUIDE TO WEDDING PHOTOGRAPHY
CAPTURING UNFORGETTABLE MOMENTS AND LASTING IMPRESSIONS

Marcus Bell

Learn to capture the unique energy and moo of each wedding and build a lifelong clien relationship. $34.95 list, 8.5x11, 128p, 200 colo photos, index, order no. 1832.

RANGEFINDER'S PROFESSIONAL PHOTOGRAPHY

edited by Bill Hurter

Editor Bill Hurter shares over one hundre "recipes" from *Rangefinder's* popular cookboo series, showing you how to shoot, pose, light, an edit fabulous images. $34.95 list, 8.5x11, 128p 150 color photos, index, order no. 1828.

MORE PHOTO BOOKS ARE AVAILABLE

Amherst Media®
PO BOX 586
BUFFALO, NY 14226 USA

INDIVIDUALS: If possible, purchase books from an Amherst Media retailer. Contact us for the dealer nearest you, or visit our web site and use our dealer locater. To order direct, visit our web site, or send a check/money order with a note listing the books you want and your shipping address. All major credit cards are also accepted. For domestic and international shipping rates, please visit our web site or contact us at the numbers listed below. New York state residents add 8.75% sales tax.

DEALERS, DISTRIBUTORS & COLLEGES: Write, call, or fax to place orders. For price information, contact Amherst Media or an Amherst Media sales representative. Net 30 days.

(800)622-3278 or (716)874-4450
Fax: (716)874-4508

*All prices, publication dates, and specifications are subject to change without notice.
Prices are in U.S. dollars. Payment in U.S. funds only.*

WWW.AMHERSTMEDIA.COM
FOR A COMPLETE CATALOG OF BOOKS AND ADDITIONAL INFORMATION